HOW TO MAKE ART

A book of ideas, inspiration, theory and practice

MEL ELLIOTT

PORTICO

CONTENTS.

Introduction 8
Get inspired 12
Stuff you could do with 18
Observation, observation, observation 20
Draw like no one's watching 24
Hand lettering 28
Drawing perspective & shadow 32
Design your own font 38
Screen printing 42
Organise, arrange & create 48
It's the little things 52
Designer labels 56
Artists' multiples 60
Working with narrative 64
Juxtaposition & irony 66
Collage 70
Drawing people 80
Colouring in 84
Using markers 92
Stop-motion animation 96
Nostalgia 100
Gouache 104
Pattern & symmetry 110
It's a wrap 114
Accidents will happen 116
How do I get my work seen? 118
Now you can make absolutely anything 120

'I could
do that.'

'Yeah, but you didn't.'

(So how do you become the one who *did*?)

INTRODUCTION

hello

I've been drawing and making things for many years now. Ever since I can remember I was always busy graffiti-ing on my parents' walls and furniture (something that my five-year-old daughter is currently helping me to see from their perspective). During all the time I have spent making art of various types, I have learned a lot, and I'd like to share some of that knowledge with you.

I have been lucky enough to have had the most brilliant art education, learning so much from the various tutors I have had over the years. By a mile, the most important thing I was taught was to LEARN FROM MYSELF ... and that isn't as philosophical as it sounds.

Being good at art isn't, in my opinion, about drawing particularly well. I know many great, wonderful and *successful* artists who make a point of *not* drawing well.

You must have heard the art critic's phrase:
'*I could do that*' and the response:
'*Yeah, but you didn't*'
So how do you become the one who *did*?

Being good at art is about knowing yourself, what makes you tick, who you like, what you dislike, the films, the fashions, your taste in music, your favourite food, and WHY?

Why do you favour certain films over others? Why do you like the work of one illustrator and not another? Being good at art is about knowing the answer to all of these things (and more) and then producing work that reflects who you are and what you're about.

At art school, you are rarely taught how to draw, how to hold a pencil, how to mix paint and all the other tricks of the trade. What they *do* teach you is how to channel yourself and how to think creatively. You are taught how to look at art, and how to understand it and appreciate it. Even if you hate it, they teach you to know *what* you hate about it – without saying, 'I could do that'.

Pearl, destroyer of walls, and ice creams.

I Love Mel HQ, Hastings, UK.

It is not always possible to have the ideal artists' studio, but there are a few key ingredients to help you get the most out of your work area:

• Light
• Warmth
• Music
• Plenty of pens, pencils and paper
• Having both a low desk and a waist-height desk is great if you have the space
• A kettle, a mug and some teabags
• A plant or two

So, in this book, you will learn how to think like an artist or designer and how to look at the world slightly differently, through the eyes of an artist. I think you'll be surprised just how easy and yet rewarding this is.

You will discover various creative techniques and 'tricks of the trade', techniques that are both traditional and new. I'll give you some great little projects and exercises to get your juices flowing, and I'll help you find some inspiration for when you are staring at that blank sheet of paper, with your head in your hands. I'll show you pencil and paper, and digital methods, but most of all I'll teach you to teach yourself.

So what do *I* do?
I had *always* wanted to be an artist of some kind, and in 2002 I decided that it was now or never, went for it, and never looked back. I embarked on my degree with my sights set firmly on going to the Royal College of Art to continue into postgraduate studies (David Hockney went there and I have always been a massive fan).

During my five years of studying, I had moments of utter confusion, thoughts of worthlessness, anger, tears, panic – but also joy, freedom, enlightenment, and pride. Lots of pride.

These days, together with my husband, I run a publishing company called I Love Mel. We mainly produce, my range of pop culture-inspired, grown-up colouring books called *Colour Me Good*, and we are about to venture into the world of children's picture books with *Pearl Power* (a story based around the little girl you saw on the previous page). I also paint and screen print whenever I get the time. Oh and I *also* create books like this!

I enjoy my job enormously and feel incredibly privileged to be able to come into my studio each day, create stuff and watch it become something. However, there are times when I am under extreme pressure, unfocused and exhausted – so please do not feel like you to have to make art and design your full time living. Sometimes it's nice to just enjoy the process. Anyway, that's enough about me, let's see what floats *your* boat!

Answer the following questions on a piece of paper, or in your journal. Do think carefully about your answers and try to think emotionally and/or visually whenever it's called for. Pretend you are on a date with yourself! Here goes:

(1) What is your favourite film? And why?

(2) Which famous person, dead or alive, do you think you can relate to and think you'd get along with? Why is that?

(3) Is there a building that you love? Is it the interior or exterior? Or both?

(4) What was the best holiday of your life so far? What was it about that holiday? The people? The scenery? The culture?

(5) Do you collect anything? You may want to look around before answering 'no' to this. Many people collect things without even realising it. If the answer turns out to be 'yes' think about how that came about.

(6) Do you have a favourite family photograph? Is it old? Or new? What are the people doing in it?

(7) Who do you follow on Instagram? What is it about their photographs? The subject matter? The celebrity? The light or atmosphere in their pictures?

(8) What is your home/room like? What do you think that says about you?

(9) Do you have a favourite shop? What does it sell? How is it decorated? How does it smell?

(10) If you were a brand, what would your logo look like?

(11) Is there an everyday product for which you particularly like the packaging/wrapper? Is it clean and simple? Is it brightly coloured or retro-looking?

(12) Who would play you in a film about your life?

(13) What is your life's dream?

Okay, now you're all set for your artistic adventure. Enjoy the ride!

GET INSPIRED

For many people, knowing where to start their creative path is a difficult challenge. It needn't be that tricky though. There is inspiration all around us. It is everywhere you look – you just have to notice it, and then embrace it.

We do not live in the 18th century any more, we do not need to meander the streets of Paris drinking absinthe (although I'm sure that is a very lovely thing to do). We live in an age where so much is accessible to us – so go ahead! Fill your boots!

Much of my time is spent not drawing or designing, but doing what many people would call 'procrastinating'. I spend hour upon hour nonchalantly perusing the Internet, flicking through image after image, not really caring what those images are. Many would consider this a pointless exercise, but for me (and I'm sure the same goes for many creatives), every so often I find something interesting and I save it. I may never look at that image again but somehow it is there, in my psyche, waiting to become a presence within my work in some shape or form.

So, the next time you're sitting there twiddling your thumbs, with a blank sheet of paper in front of you, frustrated and stuck for ideas, don't just sit there racking your brain, that's not the way to get ideas.

Instead, open a magazine, or a book. Go out onto the street, pop to the shop, or do what I usually do and 'faff about on the Internet'.

Below is a list of websites that I visit frequently: give them a go:

fffound.com is a great site that allows users to load their favourite images. The more you reflect your taste, the more images aimed at you are available to view. It is filled with great photography, illustrations and images that are often impossible to categorise. You'll happen upon influences that you would never dream of searching for.

swiss-miss.com is the visual archive of Tina Roth Eisenberg, a Swiss designer based in New York. Tina has a great eye for product design, and whether or not this is your thing, a unique and innovative idea is always inspiring.

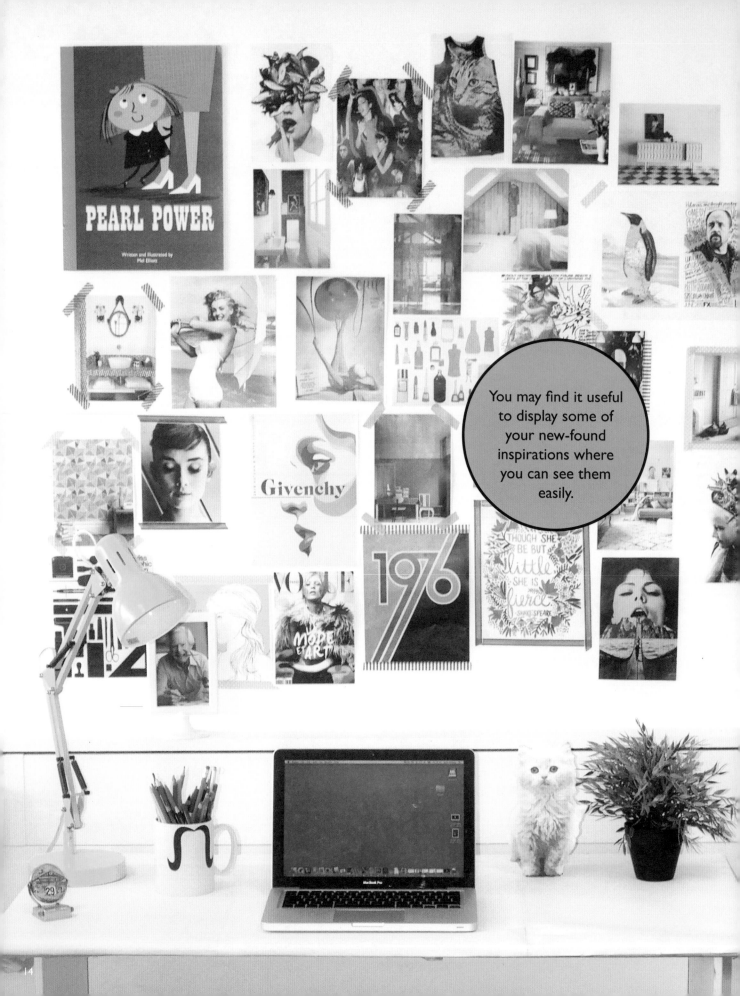

You may find it useful to display some of your new-found inspirations where you can see them easily.

creativemarket.com features a host of design, illustrative and font downloads, many of them free of charge! (The neon lettering seen within this section was downloaded from there at minimal cost.)

core77.com Formed in 1995, Core77 is a great meeting place for creatives, featuring discussion forums, jobs, exhibitions and many more events organised by its users.

behance.net and ycn.org feature many online portfolios – good ones though. Looking at other people's work is always a good idea!

For more great art and design inspiration try:

patternity.org
thisisnthappiness.com
butdoesitfloat.com
youthedesigner.com
designinspiration.com
saatchiart.com
tate.org.uk

Interior design blogs are also a great source of inspiration. You may think, 'Hey I'm too hip and cool to be looking at cushions and plant pots', but give it a go. These places are full to the brim with pattern, shapes, excellent design, interesting colour palettes and art. Here are some of my favourites:

designsponge.com
apartmenttherapy.com
houzz.co.uk
icreatived.com
design-milk.com
emmas.blogg.se

Online magazines are also a great resource. Try:

dazeddigital.com
thelovemagazine.co.uk
i-d.vice.com
vice.com
rookiemag.com
interviewmagazine.com

Okay, now you've sat and looked at image after image on the Internet, it's about time you got dressed and ventured out into the big wide world. It's time to look at stuff in 3-D!

Go to galleries – and not just the big ones. Check out your area for small independents or open days at artists' studios: you never know what you might stumble across or who you could meet.

Go shopping – I don't mean to spend loads of dosh. There are some great shops out there, with fantastic, well-designed products, often displayed in the most creative ways. Don't forget to check out the windows too!

Take a moment to appreciate nature – gaze at the sea, walk in the countryside and check out different textures, head into a forest, go to the zoo or just sit in your back garden watching the birds.

Appreciate the everyday – people-watch, check out their stance and gait, the way they eat or the way they speak. Check out all the interesting buildings around you (making sure you look all the way up) imagining what goes on up there. Check out the way people drive or the way they negotiate public transport. Look for random things on the street.

Watch TV and films and listen to music. But try to venture away from your usual choices. Do so with your new creative eye ... observe.

Buy books. Millions of them. And keep them displayed with easy access.

Keep a journal. Whether it is an online blog or a traditional Moleskine that sits deep inside your breast pocket and goes with you you wherever you go, record and track your movements, what you've seen, what you've loved. Photograph things or sketch things. As human beings, we take in so much visual stimulus without even realising, it's easy to forget the things that seemed unimportant, however inspiring they were. Keeping a journal is a great way to locate memories like this as and when you require them.

The world, whether it's the real or the online version, is packed to the brim with interesting material to influence and enhance our creative practise. Sometimes it is difficult combining this with our everyday lives, but the more inspiration you can gather on a daily basis, the better.

'Those who do not want to imitate anything, produce nothing.'

Salvador Dalí

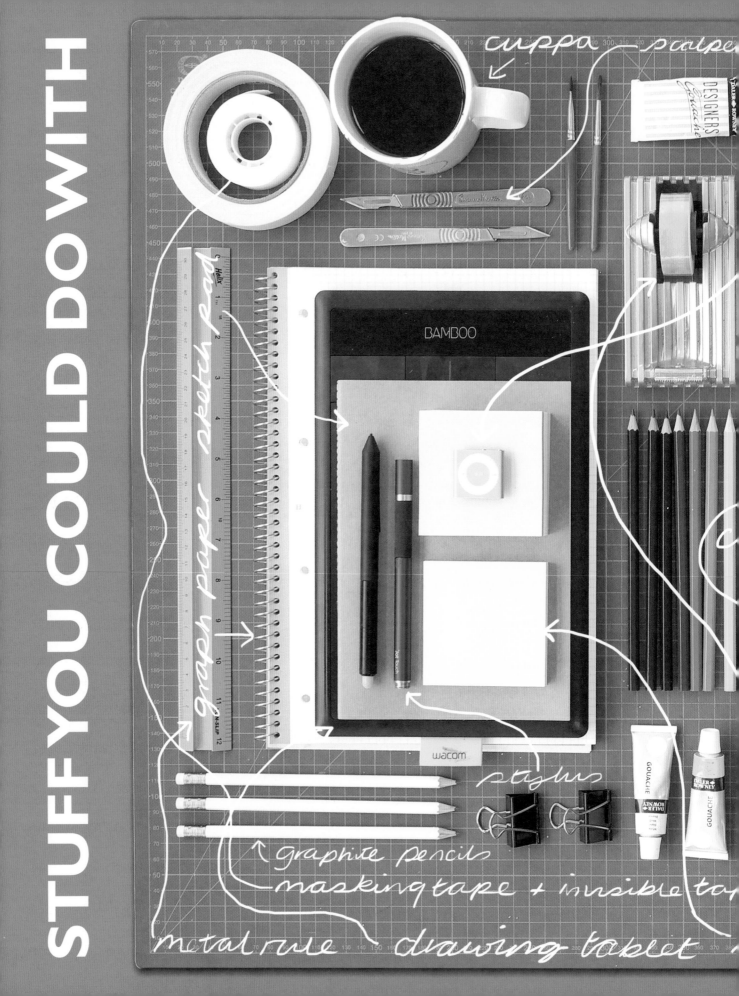

STUFF YOU COULD DO WITH

cuppa scalper

DESIGNERS Gouache

graph paper sketch pad

BAMBOO

wacom

stylus

graphite pencils

masking tape + invisible tape

metal rule drawing tablet

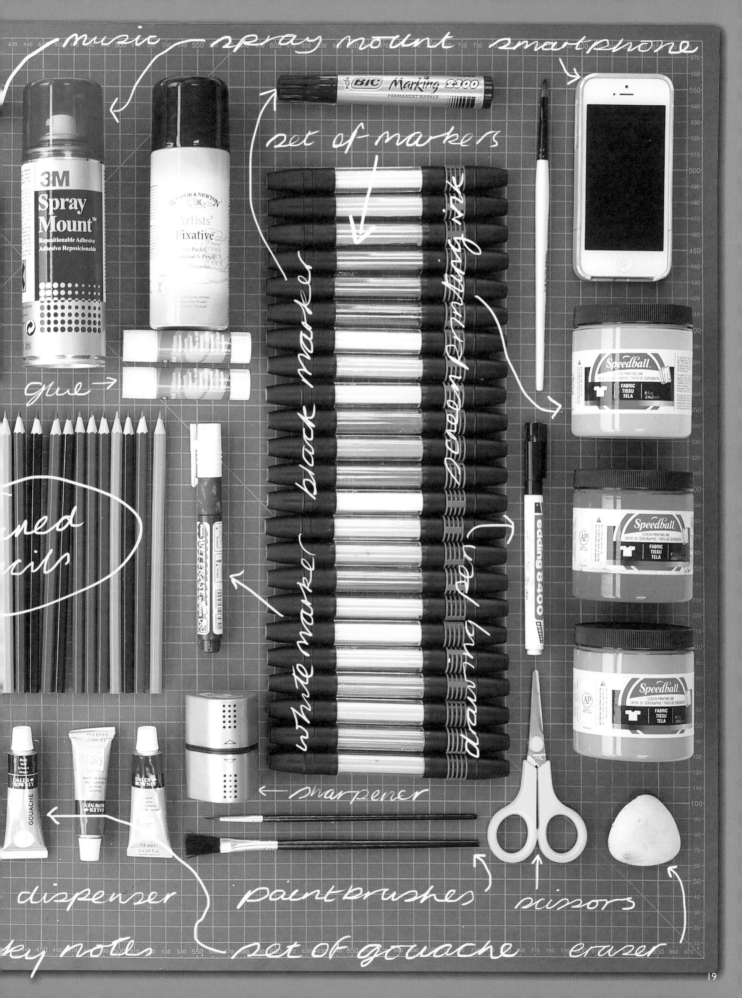

music

spray mount

smartphone

set of markers

3M Spray Mount™
Repositionable Adhesive
Adhesivo Reposicionable

glue

Artists' Fixative

BIC Marking 2300
PERMANENT MARKER

screen printing ink

black marker

Speedball
FABRIC
TISSU
TELA

...ned
...cils

white marker

edding 8400

Speedball
FABRIC
TISSU
TELA

drawing pen

sharpener

Speedball
FABRIC
TISSU
TELA

GOUACHE
DALER ROWNEY

scissors

dispenser

paint brushes

...y notes

set of gouache

eraser

19

OBSERVATION
OBSERVATION
OBSERVATION

I cannot stress how important this is.

Whenever people ask me, 'How do you draw so well?' The answer is quite simple. I look at stuff. I look at stuff A LOT. I notice minute details on everyday objects, or on people, that others just let pass them by. I notice how ripples on water separate into three or four block colours. I notice the blueness in skin tones. I notice how tea in a cup has a rim of shining light around it. I notice reflections is shiny things and shadows on wooden things. I just take it all in, but many people don't.

Ask yourself something: what colour is a diamond? Not a ruby or a sapphire or an emerald, just a bog-standard priceless diamond. If you had to draw and colour a diamond, and your life depended on it, what colours would you use? Would you notice the colours, even if you had a huge diamond right in front of you?

So, the first and most important tip in this book is to NOTICE MORE.

Don't spend your life on this planet, simply letting things pass by. Notice the colours, the shapes, the lines, where shadows fall, where things go out of focus. Notice the way rain appears on a window pane, or the way paint on a car forms different shapes and colours. At the risk of sounding like a middle-class hippy, there really is lots to see. It is really beautiful. It's all there for you to just ... notice.

So, once you have spent a bit of time gazing at things (do try not to stare too hard at strangers, it makes them nervous), start drawing stuff. Here is a list of some things that require a certain amount of your new-found skill: observation.

A chrome tap

Tea in a cup

Your mobile phone (and the reflection in its screen)

A diamond

A spoon

A glass of water (with a straw in it)

A dog's wet nose

An origami shape

The aim of this drawing exercise is more about observing the different colours and textures than your finished result. Drawing something will always make you notice more of the small details. Use the medium that you're most comfortable with, coloured pencils, watercolours, whatever.

This is a diamond.

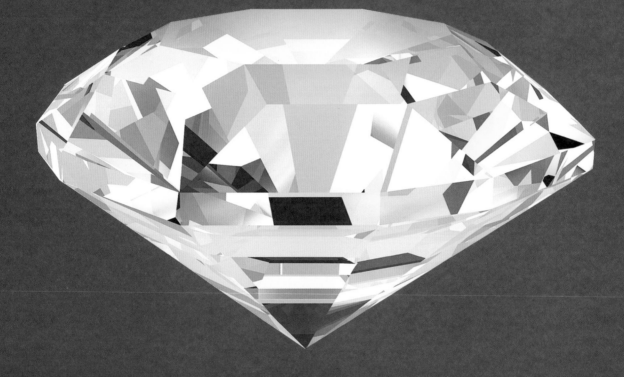

Is it how you imagined?

It's actually made up of lots and lots of small shards of flat colours, in blues, greys and greens. Look at it really closely. And try to make a habit of doing the same with everything and everyone that passes you by.

Sometimes it is easier to 'see' something properly if you take a photograph of it and then observe that instead.

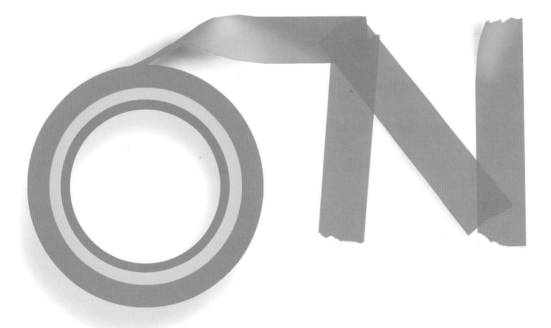

For example, to help me create this tape 'ON' illustration, I first created it with real washi tape, in order to help me determine where shadows fell, how tape looked layered up and, basically, how to simplify something quite complex.

Once you've learned how to look – you'll never look back!

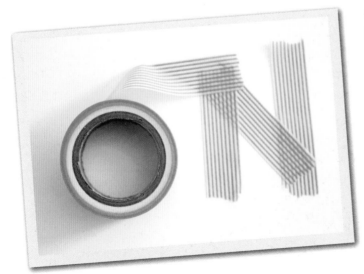

'DRAW
LIKE
NO ONE'S
WATCHING'

Mel Elliott 2014

I'd like to offer you a little challenge.

Buy a new sketchbook, one that is small enough to carry around. Then get a drawing implement, whatever your preference is, and then spend one week drawing just about everything you see.

For example: wake up on Monday morning and draw your alarm clock, draw your slippers, draw your breakfast cereal, and your toothbrush and toothpaste, and so on and so on, I think you get the picture (excuse the pun).

The key to this little task is not to produce heart-stopping masterpieces, it is to overcome your shyness. Yes, remember the first time you did karaoke and felt like a right idiot, well you'll feel exactly the same the first time you are drawing in public and people start peering over your shoulder to see what you are creating. It is a little embarrassing, but you get completely used to it, to the point where you can forget that there's anyone sharing your drawing space at all, whether that be the bus, beach, park or doctor's waiting room. Just go for it, sketch quickly and freely. Most importantly, draw like no one is watching.

Okay, so to draw everything for a week would take up quite a bit of time, so I'm going to be helpful and give you a daily schedule that you can stick to, or not:

MONDAY
Start early: draw your toothbrush, toothpaste and breakfast. Maybe venture into public drawing by taking two minutes to draw your takeaway coffee.

TUESDAY
If you take public transport to work, college or school, draw another passenger, or if you're up to it, several! Do the same on the way home.

WEDNESDAY
Forget Instagramming it ... DRAW your lunch! In fact draw ALL your meals today.

THURSDAY
You should be slightly used to drawing in public now. So how about at lunchtime, you pop into a nearby park or garden, sit down with your sandwich and draw what you see: trees, squirrels, your sandwich, people etc.

FRIDAY
This is quite a scary one, but if you're like me and like to join friends for a drink after work, take out your sketchbook and draw the beer, the bar staff and/or your friends.

SATURDAY
If there's a gallery not too far away, go and draw there. Use what's local to you. Beach? Forest? Mountain? Go for it!

SUNDAY
Sunday is animal day. Animals are great to draw, so go to the local zoo, or rescue centre. If that's not possible, sit in town and draw people's pets, draw your own pets too.

Over your shyness now? Then draw your shyness packing its bags and skulking away!

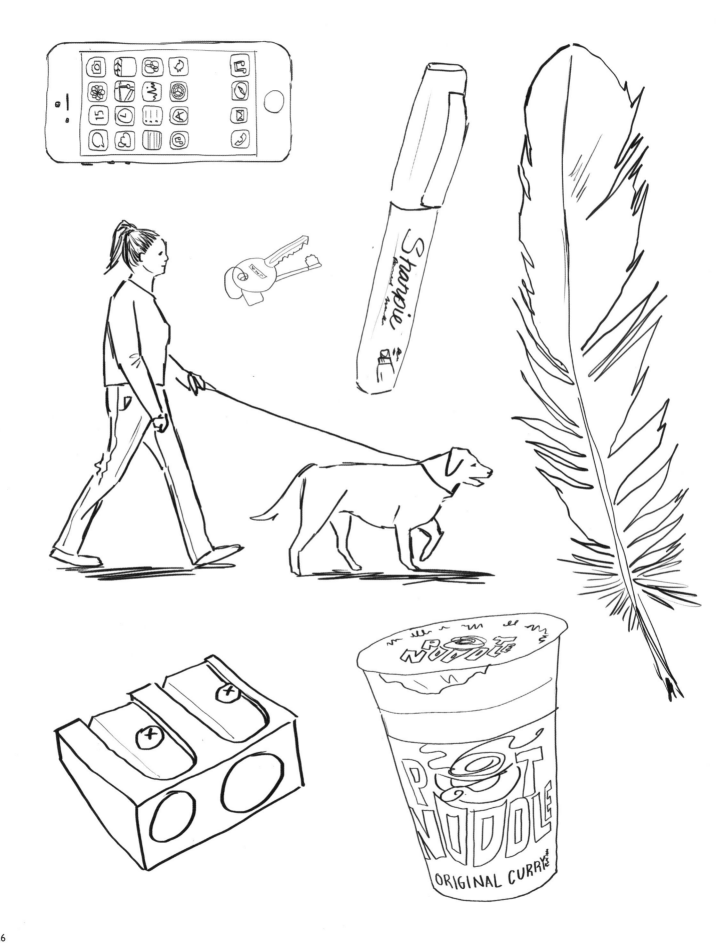

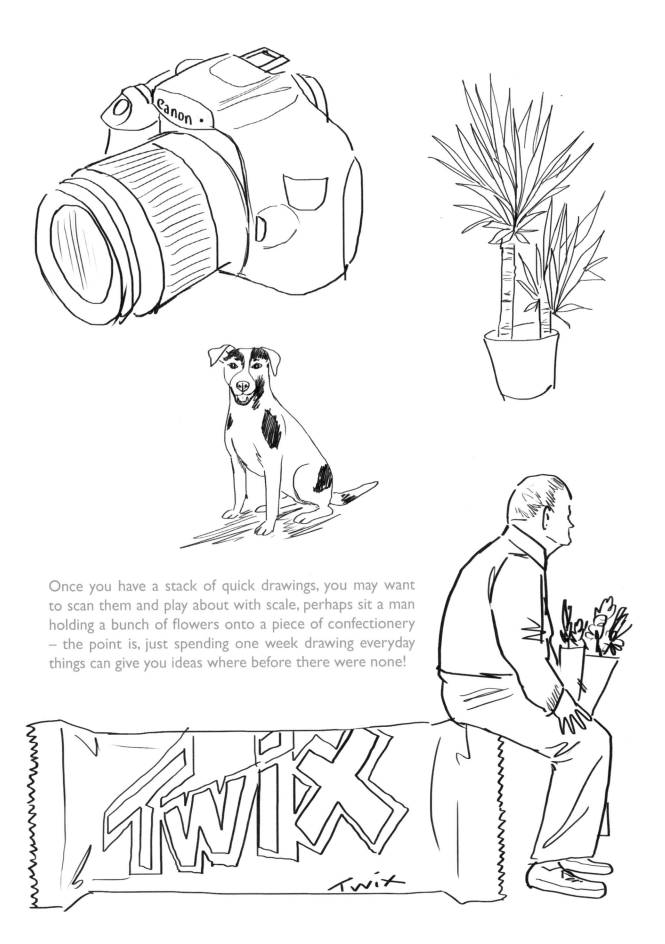

Once you have a stack of quick drawings, you may want to scan them and play about with scale, perhaps sit a man holding a bunch of flowers onto a piece of confectionery – the point is, just spending one week drawing everyday things can give you ideas where before there were none!

easy

Hand

Lettering

Hand-written type is all over the place at the moment. If you can master the art of quirky, rough, wobbly text, you're sorted and the world's your oyster.

So here's a little taster to get you started:

(1) Type whatever you'd like to say, in a plain font (something like Helvetica, Arial, Gill Sans for example), start with all caps for now. Use a decent size – 36pt and upwards. Try not to spell anything wrong within your typed text, as when you start to draw your lettering, your hand has no delete key.

(2) Print out your text. Then using either a tracing pad, layout pad, or some cheap copy paper, loosely trace the lettering with a fine, black pen. The key is to be quick. If you concentrate heavily and are too accurate, it will not look organic. Relax and go with the flow! You can always start again. If you want to be really wild, hold your pen nearer the end to give you less control, or, depending on whether you're right or left-handed, try using the other one!

Here's a little example.
So, if your printed font is like

your traced by hand version
should look more like

 Obviously, it looks rubbish right now but we'll do more with it in a while.

So, when you have done this ...

You will end up with this:

I LOVE MASHED POTATO, I COULD EAT IT ALL DAY LONG!

Not sure what to write? Go back to your questionnaire answers, that's what they're there for. To inform your work!

Now, you have your basic text, there are a few things you can do you embellish it a little. Give it that real hand-drawn look.

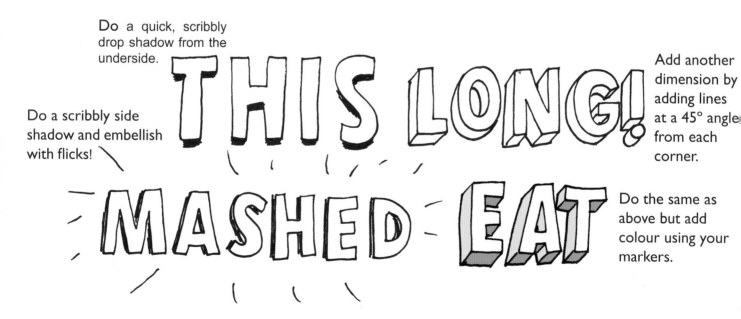

Do a quick, scribbly drop shadow from the underside.

Do a scribbly side shadow and embellish with flicks!

Add another dimension by adding lines at a 45° angle from each corner.

Do the same as above but add colour using your markers.

THIS LONG! MASHED EAT

I LOVE MASHED POTATO, I COULD EAT IT ALL DAY LONG!

By scanning your original text and placing it into Adobe Photoshop or a similar programme, you can have lots of fun simply by using the colour fill bucket. This took two minutes! For the bottom line, I copied and pasted each letter, filled the original letter in pink, then shifted the copied letter (up and to the left) slightly to create the shadow. Also, removing the holes from letters like O, A, D and P is a good trick!

drawing PERSPECTIVE

AND SHADOW

Here comes the science bit. Sorry.

No matter what your drawing and making style is, there are some things that are vitally important to know. Things that are akin to holding a knife and fork or tying your shoelaces. They are quite simple things too, so please don't go running off.

The first is perspective, which is basically drawing shapes and adding depth to them. And while I'm about to show you how to draw perspective using simple cube shapes, the same basic principles apply, whether you are drawing a house, a horse, a box of cereal, a car, a bicycle or any other 3-D object.

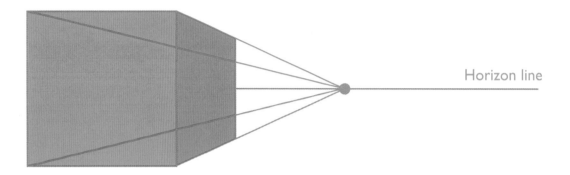

Horizon line

On the diagram above, you will notice that I have drawn a line: that is the horizon. On that line is a spot, also known as the vanishing point. Your eyes can see all over the place, but a drawing has to be specific and be from one singular viewpoint (unless we're talking about something abstract). In order to do this you must look ahead and determine your horizon line and your vanishing point.

If we were using one-point perspective to draw the scene on the right, the horizon line and vanishing point will be in red, and we'll see how we can make many of the lines within the scene meet there. One-point perspective will not leave you with the most accurate of results, as much of it is forced.

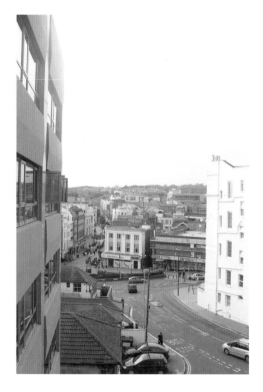

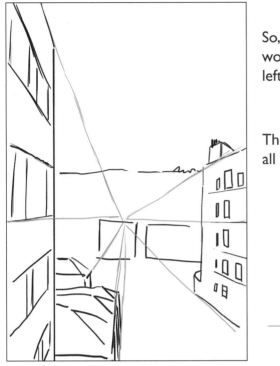

So, using forced one-point perspective to draw the scene, would give you a result something like the picture on the left.

The diagram below shows how many shapes can be drawn, all meeting at the same vanishing point.

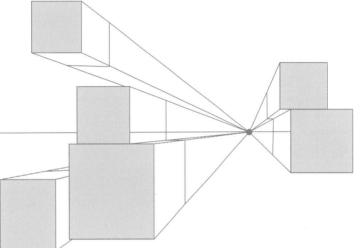

TWO-POINT PERSPECTIVE

Using two-point perceptive is only slightly more complicated, but gives much more realistic results. In terms of horizon lines, the same rules apply, however, rather than having to pinpoint one vanishing point, you select two.

See the example below for how this method is used to draw a simple cube.

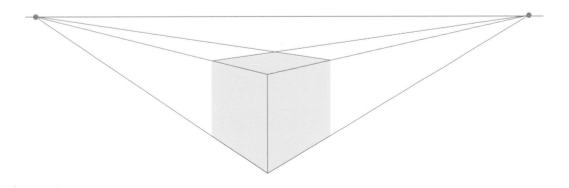

And how it would be used to draw several shapes.

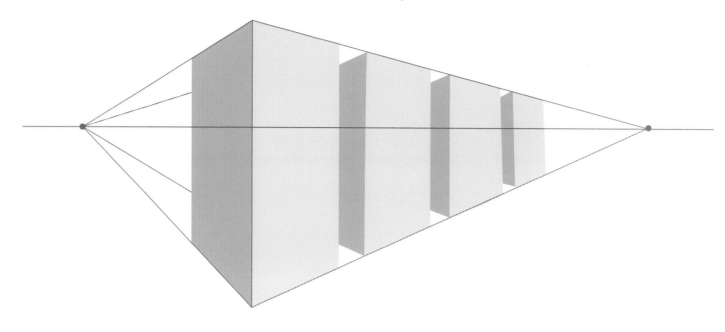

THREE-POINT PERSPECTIVE

Three-point perspective uses the same principles but adds a further vanishing point either below or above the horizon line. The image on the left is a worm's eye view, i.e. with the third point above the horizon, creating a view from below. The image below shows a bird's eye view, i.e. vanishing point below the horizon line, giving a view from above.

Just as perspective creates depth in your work, light and shadow also play a huge part.

Take this cube for example, it doesn't even resemble a cube, does it?

But add a light source and hey presto!
You have a cube!

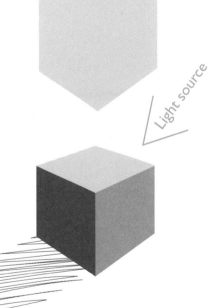

Light source

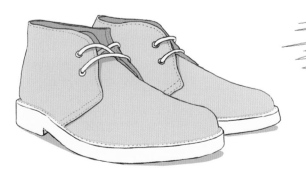

And check out the desert boots on the left. The shadows are so small, yet make such a huge difference to the overall image.

Design Your Own FONT

Those of you who have bought my colouring books may have noticed that I often use my own fonts in them.

This is one of them, and thanks to a great iPad app, they're incredibly easy to make.

You can keep it simple and just recreate your handwriting so that you never have to pick up a pen again, or you can go all crazy and playful LIKE THIS!

Do have a go, it's great fun.

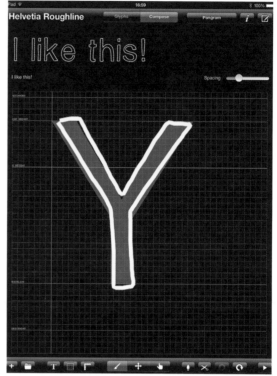

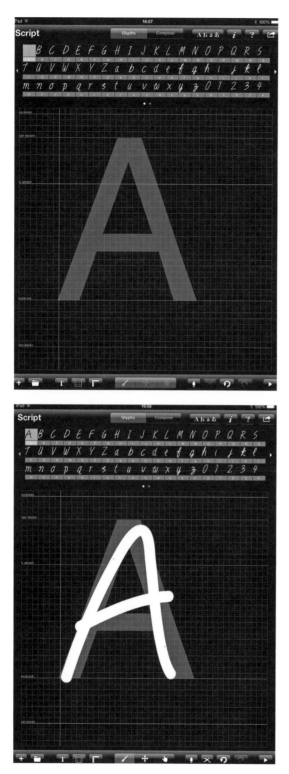

iFontMaker is a fantastic app that helps the noviest of novices develop their own typeface. The app is inexpensive and you can create as many fonts as you wish.

Using a stylus or even your finger, you can go completely off-piste, or use an existing font to help you with sizing, spacing etc.

The programme takes you, letter by letter, through the entire alphabet, in lower and upper case. It then takes you through numbers and then punctuation marks and other symbols.

Once your font is complete, you can then download it straight to your computer in three incredibly easy steps! YAY!

The quick brown fox jumps over the lazy dog

THE QUICK BROWN FOX JUMPS OVER THE LAZY DOG

The quick brown fox jumps over the lazy dog

The quick brown jumps over the l

All these fonts were created in minutes and are now available within my creative suite to use whenever I fancy something a bit more personal to me.

SCREEN
PRINTING

Screen printing was developed in the early 20th century as a method of reproducing commercial images and signage relatively cheaply (before this everything would have been done by a man with a brush and a ladder).

By mid-century the technique was being explored by artists, with a 'serigraph' being the name used to describe an *art* screen print, due to the fact that increasing numbers of creative people were using the technique.

You will all be aware of Andy Warhol's Campbell's Soup Can screen prints of 1962. This, and Warhol's continued use of screen printing as an art form, have made it a technique enjoyed by many artists and designers throughout the world.

It can be used on many surfaces: T-shirts, mugs, wood, metal – just about anything, but I'm going to talk to you about screen printing onto plain old paper.

Mini-screen printing kits for home use can be bought, cheaply, from many art suppliers, but to fully embrace this rewarding technique, creating your own studio in a garage or workshop is one way to gain experience. Better still, find out if there is a screen printing studio or workshop in your area. Pay each time you use the facilities, leaving your home nice and splatter-free! Most public screen printing studios will offer a short course in learning the basics and then they will let you use their facilities as and when required.

(1) While screen printing can be used for incredibly complex designs, when starting out, the key is to keep it to a minimum. Design an image with fairly simple shapes and flat colours.

(2) For each colour that makes up your image, you will need a separate screen, so when starting out, it is easier to create something with just two or three colours.

(3) There are various ways of creating your film positive. The easiest, I find, is to scan your image and then separate each colour in a programme such as Photoshop. You must print each colour area as black, separately, onto thin paper or film (see the colour separation diagrams on the next page).

While I have vastly simplified the instructions here, screen printing is a fairly complicated business. However, the learning curve is great fun and even if the results aren't exactly how you had planned them to be, they are often pretty interesting and far too good to throw in the bin.

The whole process forces you to think about your artwork and creative process slightly differently. While it is entirely possible to print in full colour (by separating Cyan, Magenta, Yellow and Black), having to limit your colour palette gets you thinking more creatively. If you do give screen printing a go, enjoy the process and the mess, and you will find yourself lying awake at night, being flooded with ideas like ink on silk.

These are the three images I created onto 80gsm paper, ready to expose onto a silk screen.

This blacked-out area represents where the fluorescent pink will feature in my finished print.

This area will form the blue part of my print.

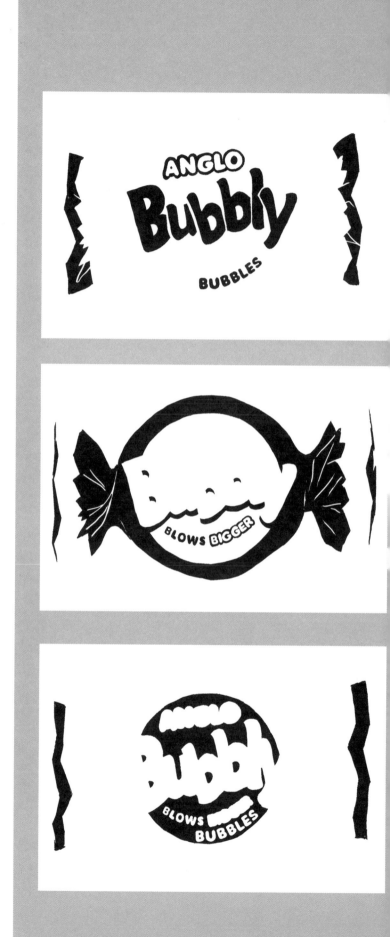

And this area will form the yellow sections.

Once all these separate colour components are produced in black, you are now ready to expose onto screen.

A thin layer of photo emulsion is put on the screen, which is left to dry. Your black images are then placed onto the screen using strong UV light, either from special lamps, or from the sun!

Once exposed, the emulsion is rinsed off, dried and then you are ready to start pulling. Above, you can see me adding the florescent pink layer.

Below is the finished print.

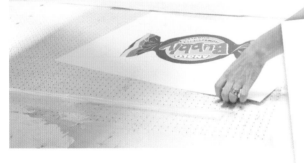

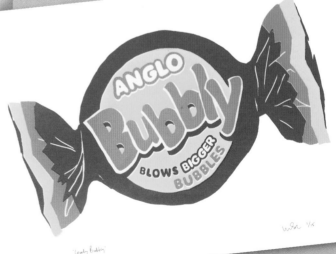

Lovely Bubbly, three colour screen print.

45

Once you have played around with printing with inks, why not try other materials? For example, you can get some great metallic inks. To make this pink, sparkly *Feminist* print, I screen printed with pink first, then with PVA glue. Next, I very quickly threw glitter all over, before shaking the excess off. Apparently, Ed Ruscha used to print with jam, beer, blood and all sorts!

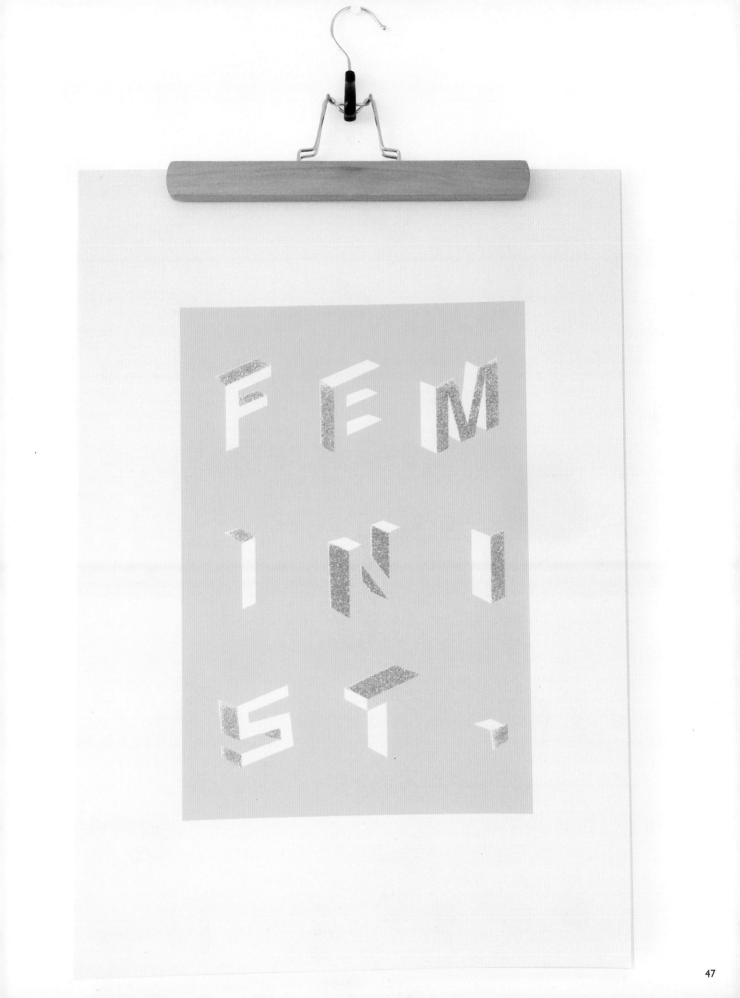

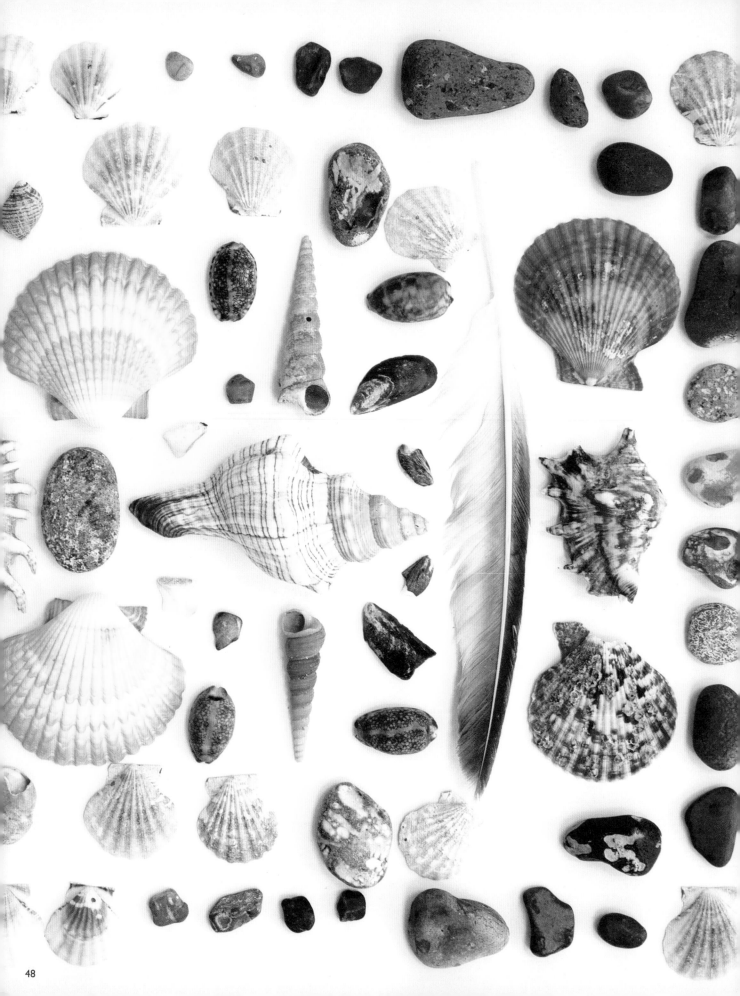

ORGANISE, ARRANGE & CREATE

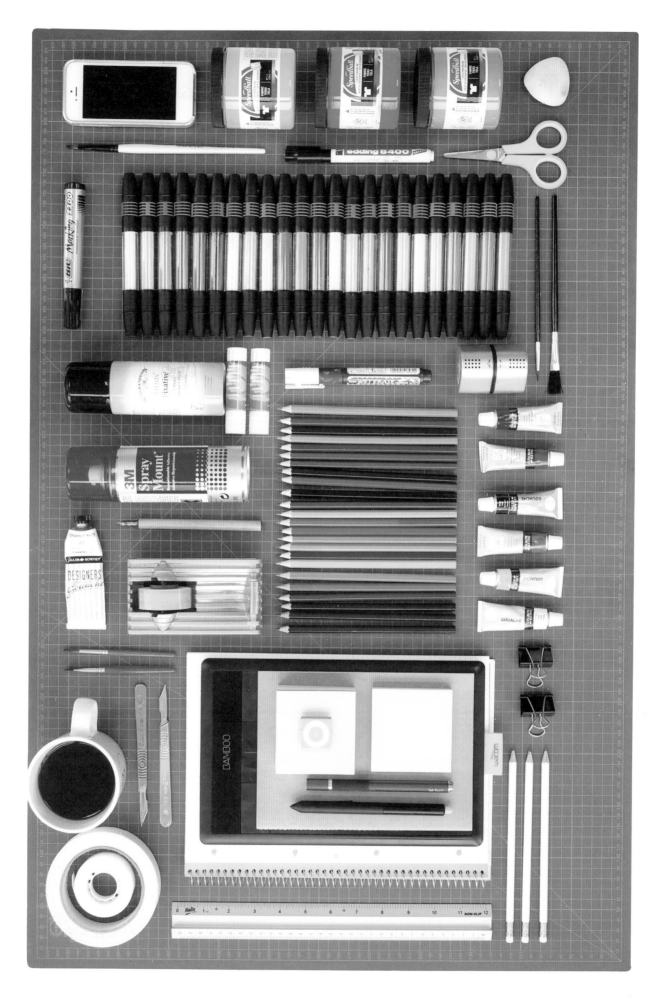

Anyone who has visited the brilliant website thingsorganizedneatly.tumblr.com will realise that sometimes you can make amazing art simply by having a tidy-up!

By organising and arranging objects, large or small, in very neat, grid-like patterns, you can create the most pleasing images.

We all have a little bit of OCD in us somewhere, it's time to let it out!

These things aren't just pleasing to look at: creating them is incredibly relaxing and therapeutic. Think about objects that 'go together', such as my art equipment opposite, think about things that are all the same (or a very similar) colour and think about things that you can simply create a brilliant pattern with.

Tip: You will need to take a photograph of your piece from directly above, so be careful how high your surface is – the floor is best.

Don't be too limited in where you search for stuff to organise. Try your grocery cupboards, rubbish you find on the street, collections from the beach, your medicine cabinet, or just go to the home of everyone you know and borrow all their yellow things!

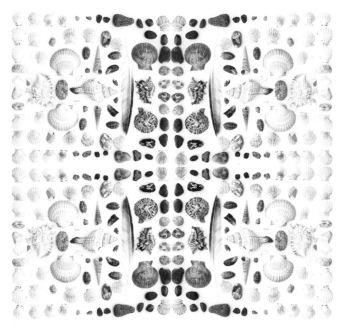

As with most projects in this book, it's not entirely about the project itself, but where that project might take you. For example, my assistant, Jack, organised the pebbles, shells and feathers. We tiled the images to give us some symmetry and realised how great the final image would look as a print ... or even on a silk scarf!

So, get some stuff, tidy up, photograph ... NEAT!

It's the little things

When it comes to making images, the possibilities are endless. However, that doesn't necessarily equate to there being no excitement or drama in a tiny little pencil drawing.

Sometimes, size doesn't matter and less is more.

So, get yourself a small sketchbook (A6/A5 but no larger), acquire some good-quality drawing graphite pencils, a carbon pencil, putty rubber and maybe a charcoal pencil and most likely, some fixative spray too. Then FILL each page of your sketchbook with a very careful and considered drawing of tiny things. Whether this is the style you want to aim for or not, try and get your drawings fairly realistic, that is the challenge here (we'll go a bit crazier with drawing later).

Here's a list of possibilities to get you started:

Fly (or any other small insect that is preferably dead or on a photograph)

Paper clip

Ballpoint pen lid

Reverse side of a pin badge

Couple of coins

Hair slide/clip

Pair of tweezers

Small roll of sticky tape

Ring pull from a drink can

Small pot of nail varnish

Bulldog clip

Biscuit crumbs

Your pencil sharpener

Wine cork

Pencil shavings

Leaf or flower bud

Small feather

What will you learn from this?

The key to this task is pencil control: how hard/ soft you should apply it to the paper, when to use softer leads or carbon and charcoal; the importance of shadow and highlights (which you will probably gain from using your eraser delicately). You will also strengthen your observation skills as drawing tiny objects requires a huge amount of concentration and noticing – perhaps even a magnifying glass!

When considering scale on this project, while your sketchbook would look fantastic with all the objects kept to their original size, think about whether you will be able to get enough detail if your drawings are only 12mm in length!

Your tiny finished sketchbook will contain some drawings that are better than others, but if you are patient and fill your book, however good or bad your drawings are, it will be a delightful, delicate little book.

Pure pencil drawings are a real (and often rare) thing of beauty. Once you have completed your tiny sketchbook of pencil drawings, you may find that it is an avenue that you wish to explore further. Many artists work predominately in graphite pencil. It is a medium that is simple, honest and sophisticated. But do not feel hampered by it, this medium can be used in the most innovative and contemporary of ways.

If you are a fan of graphite pencil drawings, do check out the work of:

Cate Halpin

Ian Hodgson

Molly Springfield

Roland Flexner

Michaela Fruhwirth

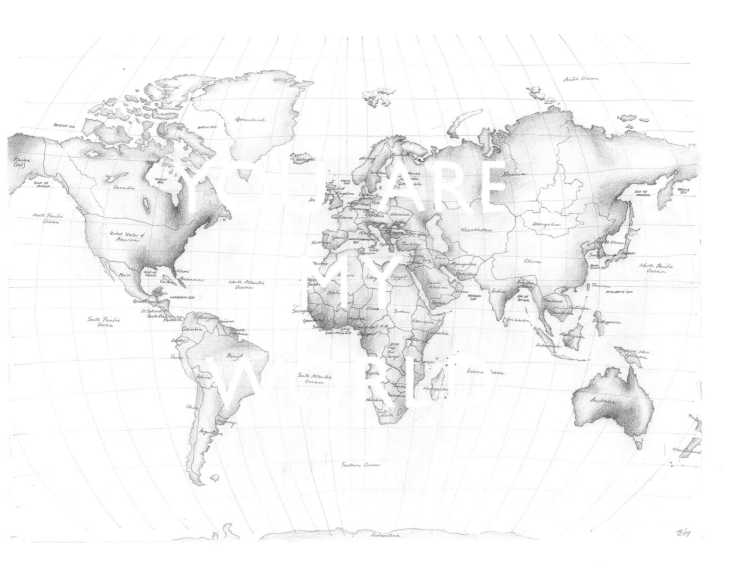

Above *You Are My World* graphite pencil with masked out lettering.
Left *Poor Cow* graphite pencil with digital graphics.

DESIGNER LABELS

While I'm dead against pigeon-holing yourself and trapping yourself in a box you then struggle to escape from, I do feel that 'defining' yourself as an artist or designer is not necessarily a bad thing. It can help to keep your work focused and it can also assist in generating ideas.

Personally, I consider myself a pop artist who has a penchant for juxtaposition, a hit of nostalgia and a crisp, clean, flat aesthetic. It's kind of like a formula, and by sticking to this formula, whatever kind of project I'm working on, the chances of me producing a good result are vastly improved.

It's about looking at yourself and your work, understanding where it comes from and then simplifying it into a few words.

Take a look at the words on pages 58–59, and see if any of them are relevant to you and your creative practice – feel free to think of your own too! If you're a complete newbie, you may need to start making some artwork in order to do this task as this shouldn't be a forced process. It's important to let these words assist your work, rather than dictate it.

If you're completely unsure, consider the words on the following pages and try to relate them to artists whose work you know of, for example:

AUTOBIOGRAPHICAL, FOLK, 3-D, PERSONAL, POLITICAL, ADOLESCENT
Tracey Emin

SHOCK, SCULPTURAL, JUVENILE, JOKE, POP
Jake and Dinos Chapman

ANIMALS, LANDSCAPE, 3-D, JOKE, PLAYFUL, CARTOON
David Shrigley

POP, SCULPTURAL, CHEESY, JUXTAPOSITION, SITE-SPECIFIC, PLAYFUL
Jeff Koons

Now have a go at guessing the artist from these two examples! (The answers are at the bottom of the page.)

(1) POP, PRINT, CELEBRITY, PRODUCT, GRAPHIC

(2) PHOTO-REALISTIC, TECHNIQUE, OVERSIZED, FIGURATIVE

Now take these very well-known artists and try to use some of the words to describe their work in simple terms (or use your own words). If you do not know of their work, do some research rather than guess:

Miranda July

Ed Ruscha

Cindy Sherman

Ron Mueck

Grayson Perry

David Hockney

Yayoi Kusama

Damien Hirst

site-specific
political
landscape
figurative
juxtaposition
naive
shock
personal
joke
still life
digital
compositional
photo-realistic
cheesy
folk
typographic
pop
3-D
sexual

irony

nostalgia

twee

oversized

cartoon

animals

playful

fashion

juvenile

graphic

sculptural

autobiographical

adolescent

literature

celebrity

product

print

technique

process

Now that you have fathomed out your work, you can take your 'words' and pop some more words in between them to form your **artist's statement!**

While I was doing my degree at Batley School of Art & Design there was one project that, for me, was a life-changer.

Before this, my time was spent producing painting after painting. Usually 600 x 800mm, using gouache and toiling and sweating over each one, striving for perfection over a period of days and then often hating the finished result – but then starting another one. The *good* paintings had two purposes: to sit on the wall of some swanky gallery, or to be bought for heaps of dosh and sit in some posh person's living room. This was what I did, it worked and I saw no point in changing my habits.

Then we were given a project entitled 'Artists' Multiples'.

A 'multiple' is a way that an artist can make their work more accessible, more affordable and therefore more obtainable. It is where the artist goes and sits on that fine line between art and design, taking their work and turning some element of it into a product (often a limited-edition one but not necessarily). It was being forced to take part in this that shaped my career as it is today. All of a sudden, I was producing tiny paintings and collecting them into a handmade book – and I've been 'booking' it ever since!

Creating an artists' multiple gets you thinking not only creatively, but also commercially. It can open the artist up to a whole new audience and, in my case, a whole new way of working.

'Commercial' isn't a dirty word!

Please check out some artists' multiples. These websites are a good place to start, but gallery gift shops are even better:

themultiplestore.org

artmultiples.net

artmetropole.com

garudiostudiage.com

Now think about your own work and how you turn it into a multiple. Basically, turn your art into a more accessible product! Here are some suggestions, but use your imagination, you can create anything:

Edition of screen prints

Book of your artwork

Postcard

Plate or mug

Piece of jewellery

Ashtray (Tracey Emin and Sarah Lucas did this)

Doll of yourself

Cardboard cut-out

Set of badges

3-D model

You never know, this project could take you down a completely different path like it did for me!

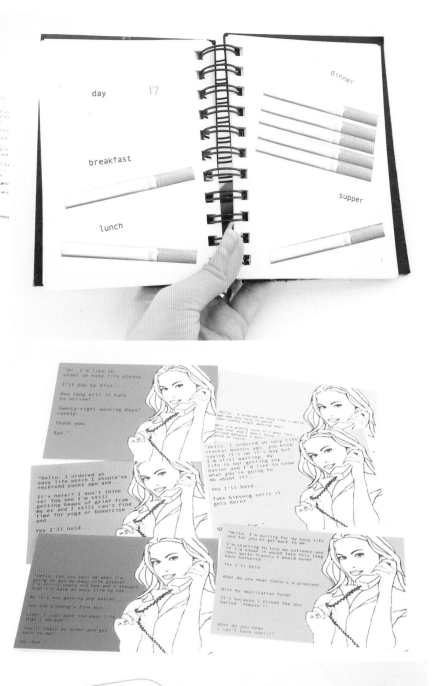

Some multiples produced by me during art school and after.

Top left *1,000 Pleases* ask-a-favour booklet. **Top right** *She Ain't Heavy* diet book. **Above** *Liverpool Street to Lancaster Gate* short storybook. **Right** *Easy Life* set of six postcards. **Below** Book of painted products. **Below right** *Seeing Double* card game.

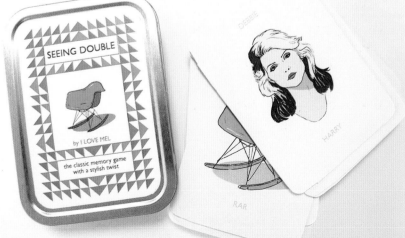

working with

NARRATIVE

You don't have to be Roald Dahl or Walt Disney to work with narrative. Many artists and designers use 'found' stories, or make up their own, to form the basis of their work. Looking at poetry, old fables or folk tales, song lyrics or even horror movie scripts, and then illustrating them with whatever medium suits you, is a very worthwhile exercise. Working with narrative of some kind helps to banish those 'idea blank' blues, and if you ever see yourself working for clients, it is the perfect way of teaching yourself the art of working to a brief.

So off you go, take your Alan Bennett monologue, the words to a Taylor Swift song, the menu for your local takeaway or even a conversation you hear on the bus … and turn that into something visual. Failing that, do what I do – and write your own! Don't tie yourself down in terms of what you produce, your results could be a painting, a comic strip, animation, screen print, sculpture or whatever takes your fancy. The aim of the game here is to take some narrative, be it 'found' or something you have written yourself, and turn it into a visual piece of work.

by a big lump of blu-tak. As I lift back up I slightly knock into the person standing behind me and turn around to apologise.

My heart sinks as I realise that once again I have made the mistake of acting hide-ously before a potential future husband and that the wedding dress that I have had in the back of my head since puberty will be smelly and moth bitten by the time I get around to wearing it!

Immediately I admit defeat with regards to any available men who sadly witnessed the shenanigans. I take my mobile from out of my bag and smile to myself, pretending that I have just received a funny text mes-sage, hopefully giving the staring crowd the impression that even if I cannot em upon a simple tube journey with digni and poise, this does n automatically that I am without fri few peopl away and I smirk at g them.

Many of the merchant bankers depart at the next stop and I sit down on the only available seat in a bid to peruse the men in front of me hoping that one of them would turn out to be the man of my dreams and sport good looks in conjunc-tion with a semi-decent job and minimal body odour, because, even after countless misjudgements, mistakes and Mr. Wrongs, I still live in a deluded sense of hope that Mr. Right(ish) is still out there, waiting for me to whisk him off to the place they call marital bliss (closely followed by extra marital bliss if things don't work out).

Directly opposite me is a fairly young man and whilst I utterly detest men with ear-rings, I remind myself that they can be easily remov I continue to consider him.

Th r poking from his rucksack te he is likely to be a student of e r business studies and I figure

juxtaposition /

n. the fact of two things being seen or placed close together with contrasting effect.

irony /

n. expression of meaning by use of words normally conveying opposite meaning. **ironist** *n.*

Besides being a wonderful word that would earn you a gazillion points in Scrabble, the use of juxtaposition in art is one of my favourite things.

Artists have been 'odd coupling' for ages. Think Salvador Dali's *Lobster Telephone*, René Magritte's *Son of Man*, Richard Hamilton's *Interior II*, which has vacuum cleaners sitting next to a muscular weightlifter.

When juxtaposition and irony meet up, well that's what I *call* an arty party! Take, for example, Marcus Harvey's *Myra*, 1995: a portrait of child killer Myra Hindley, formed from the tiny hand-prints of young children. Gavin Turk's *Nomad, 2003*: a life-sized sculpture of a polyester sleeping bag (something that would be incredibly light and throwaway) that is actually made from painted bronze. And Grayson Perry's earthenware vases (a decorative object usually adorned with flowers or pretty patterns) illustrated with dark, disturbing scenes of murder, violence and tragedy.

Do check out more examples of juxtaposition and irony within art and design at:

subversivecrossstitch.com
miriamelia.co.uk
magdaarcher.com
jeffkoons.com
starck.com

But also look out for it within TV advertising, my *Feminist* screen print (page 47) and my *Tracey Emin v The Spice Girls* blanket opposite (although you should look at Tracey Emin's blankets first).

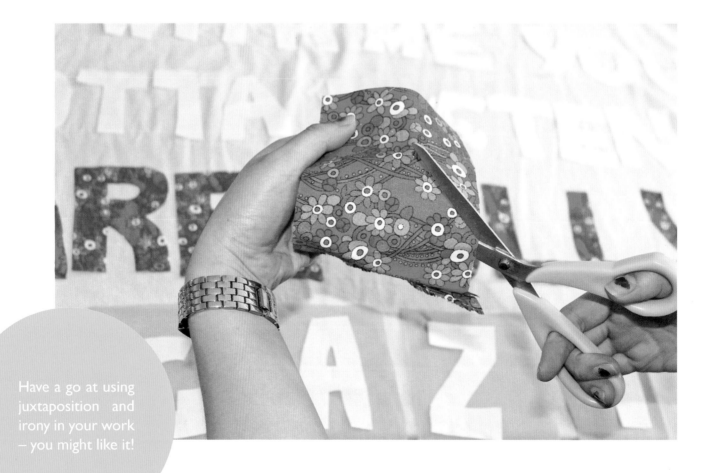

Have a go at using juxtaposition and irony in your work – you might like it!

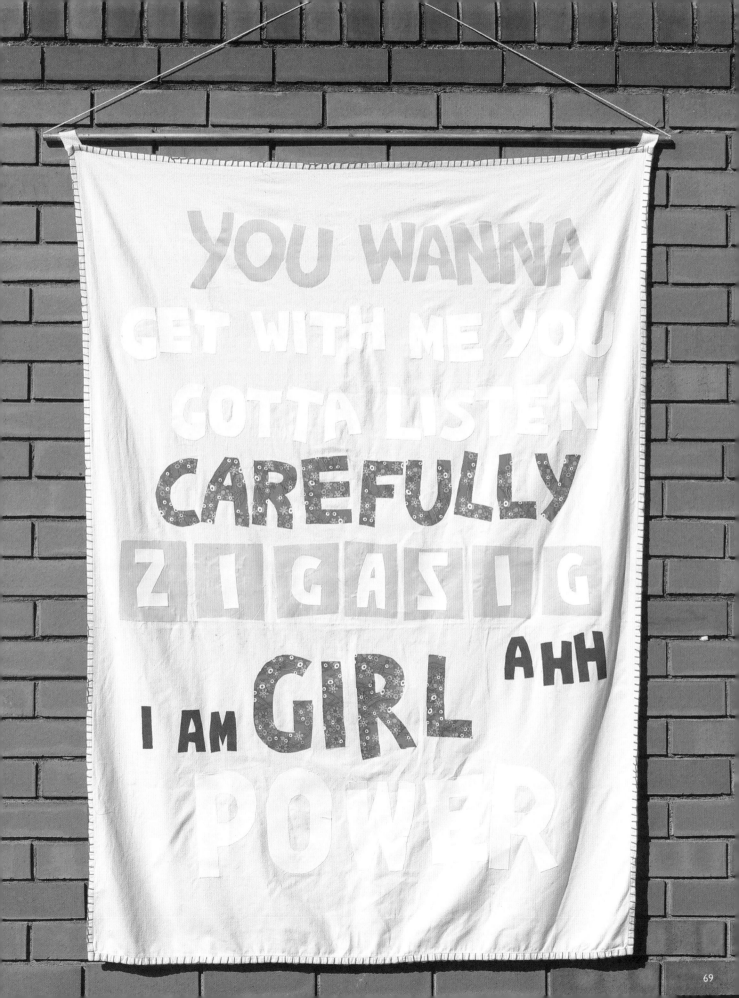

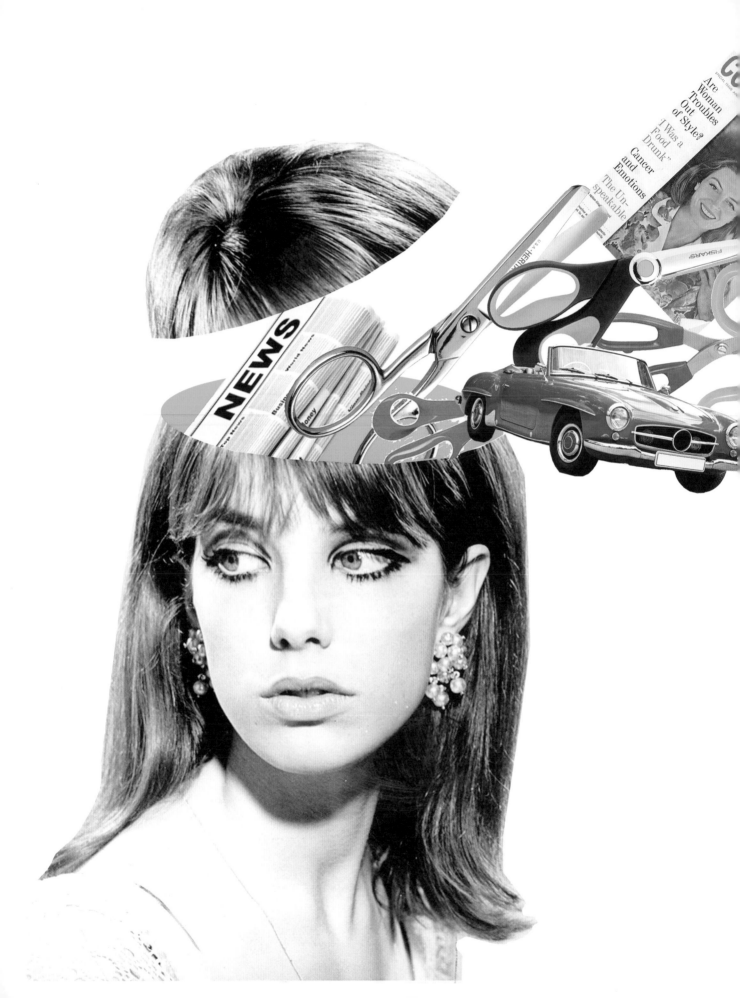

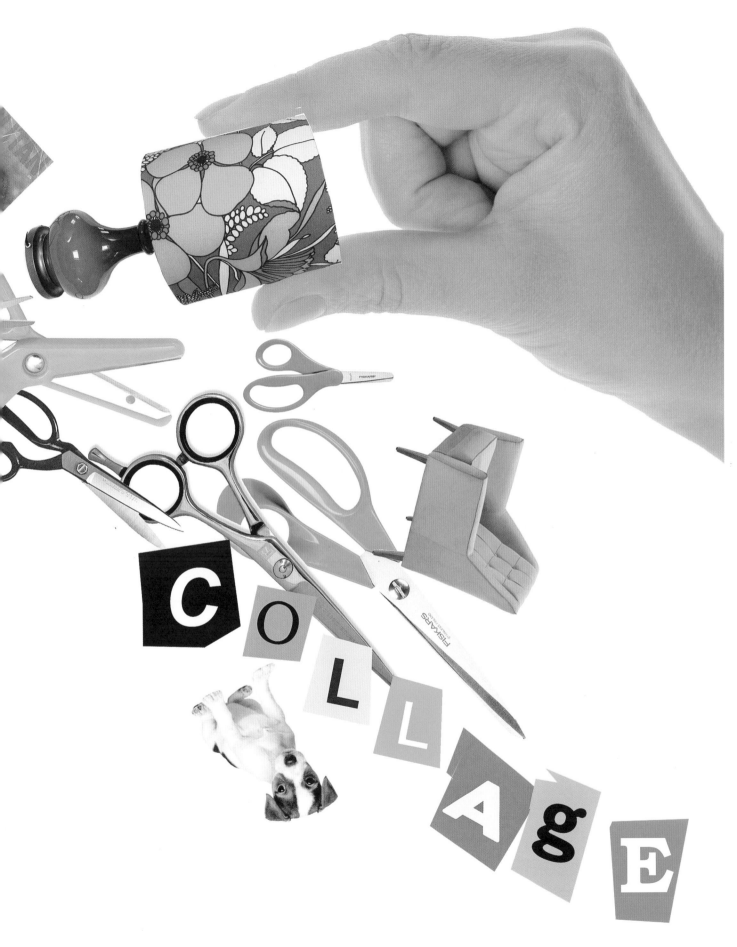

When my degree tutors asked me to do some collage (no, make that *forced* me to do some collage), I conjured up images of me, in nursery school, cutting up the *Freemans* catalogue with a pair of those kiddy-scissors that are made completely of plastic. The only joy I got out of this was at the end of the afternoon when I could sit and peel PVA glue off my tiny hands (usually glue that I had daubed on them deliberately). Being the philistine that I was, I had no idea of the pure brilliance that can be created through cutting and pasting.

Being a collage artist is the closest you can get to being GOD!

Want a puppy and a load of scissors to fly out of Jane Birkin's head? Do it!

Many collage artists work in high volume i.e. maximising the space with tons and tons of tiny little things going on. Other artists play with scale, thus creating fantastical, surreal images.

Since my little diva moment all those years ago, I have become a big fan of collage art and I wish I was *much* better at it.

So, while my purpose here is to tell you how great collage can be and roughly how to do it, do yourself a favour and check out the fantastic work of these people in order to see for yourself what can be achieved by cutting up bits of paper:

Hugo Barros
Richard Hamilton
Hannah Höch
Peter Quinnell
John Stezaker

Sammy Slabbinck
Jordan Clark
Nazario Graziano
Zabu Stewart
Ashley Joseph Edwards

There are a few different ways of producing collage:

(1) The traditional method – taking newspapers, magazines, catalogues, old wallpaper or even fabric, and physically cutting out items with scissors or a sharp craft knife. Then arranging your image before sticking your pieces down with non-permanent spray adhesive (this adhesive allows you to remove and replace items should you make a mistake or change your mind).

(2) The digital method – this involves taking a programme, such as Photoshop, and using this, along with digital image files, to do all of your cutting and pasting (there are some brief instructions opposite). This method isn't much less time-consuming than the traditional way, but it saves a whole heap of mess and allows you complete freedom in terms of scaling images.

(3) 3-D collage – once I had dragged myself out of my 'collage is for toddlers' stage, this is how my work started panning out. Taking a fictional scenario, and using a mixture of cut-out images and drawn images, to create a great piece of stand-up collage (instructions on page 76).

(4) 'Jigsawing' – creating a new image from a single picture by chopping it up and rearranging the pieces.

When you place your images (by going FILE > PLACE EMBEDDED or EDIT > PASTE) into Photoshop or similar, you will most likely then have to remove the background. If the background consists of similar colours and is in sharp contrast to the item you wish to keep, you can use the magic eraser tool.

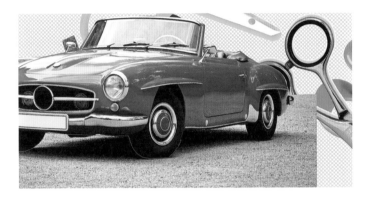

Another way is to use the POLYGONAL LASSO TOOL.

You can use this to roughly draw around the background and delete, piece by piece.

Then you are ready to position your item wherever you fancy – you may want to rotate it too (EDIT > TRANSFORM > ROTATE).

Puppet Warp	
Perspective Warp	
Free Transform	⌘T
Transform	▶

Again	⇧⌘T
Scale	
Rotate	
Skew	
Distort	
Perspective	
Warp	

Auto-Align Layers...
Auto-Blend Layers...

Define Brush Preset...
Define Pattern...
Define Custom Shape...

Purge ▶

Adobe PDF Presets...
Presets ▶
Remote Connections...

Color Settings... ⇧⌘K

Rotate 180°
Rotate 90° Clockwise
Rotate 90° Counter Clockwise

Flip Horizontal
Flip Vertical

You can also change the size of your item by using the EDIT > TRANSFORM > SCALE tool.

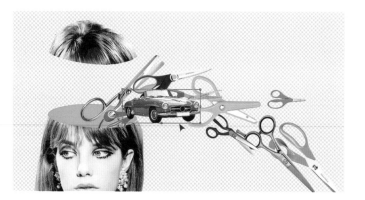

The image shows the car having been rescaled and positioned into place.

This image shows another background being removed manually using the ERASER TOOL.

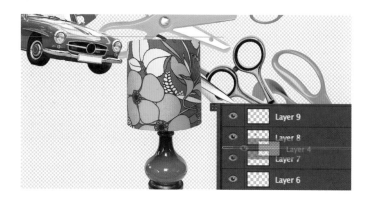

Your placed items will all appear on separate LAYERS. You can easily change the order of the layers by just dragging one above another in the LAYERS PANEL.

Collage does not necessarily have to be made up of many images. Below is a simple photograph of my daughter skipping along Bottle Alley in Hastings. By cutting out sections, rotating and rearranging within the frame, I have given this photograph a whole new perspective.

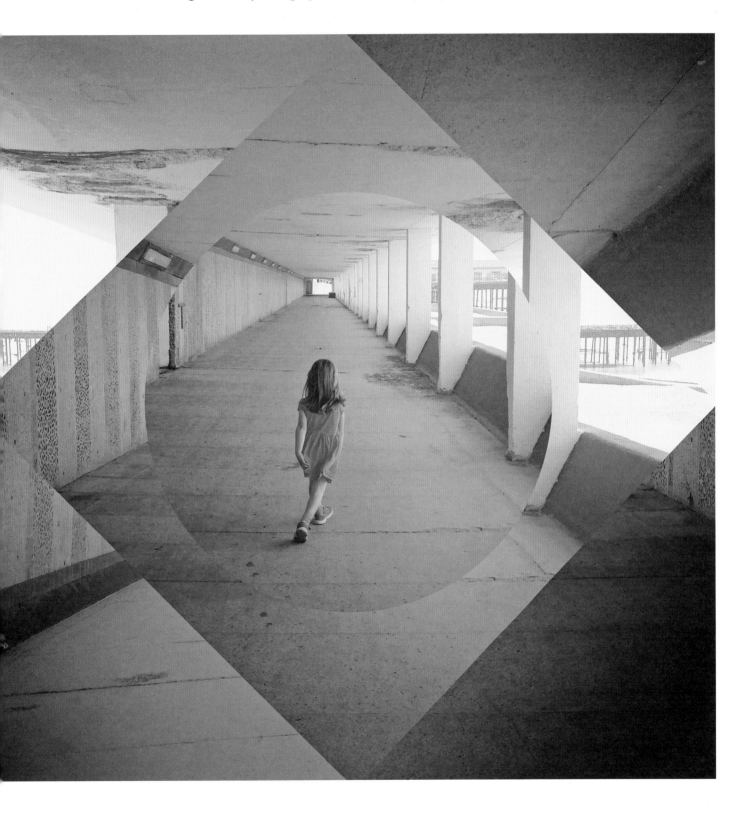

1

3

4

6

I rarely set out with a plan when making a collage and they are largely dictated to me by what I come across while nonchalantly flicking through magazines. I love magazines, a little bit too much. I collect them and have hundreds and hundreds lined up in chronological order in my studio. Therefore I do not cut them up for collages. What I *do* cut up, though, are the little supplements that often come with magazines. I also cut up catalogues, brochures, leaflets and anything else I can get my hands on.

Often, when I am looking for things to put into my collage, the items I am drawn to end up telling me a story. What appear to be completely random people and objects, when placed together, make the most obvious of scenarios.

Give it a go yourself: collect and cut out some things you like and then see what they say to you when you bundle them together.

This is also a really nice way of deliberately illustrating a piece of narrative.

1. Flick through your magazines, marking any pages with things that may look good in your collage.
2. Using your scalpel/craft knife, roughly cut out your chosen items.
3. Perhaps add items together!
4. Use spray adhesive to stick your items onto foamboard, and then cut this out …
5. … until you have a firm, cut-out item that you can stand up.
6. Repeat the process for all your chosen items.
7. Use more foamboard to make stands to attach to the back of your cut-out items; stick on using your PVA glue or some tape.
8. Start layering up and arranging your items, then take some photographs!

And here we have the disturbing tale of a man who, at five to midnight, goes completely psycho in his flat. He takes a huge knife and kills his girlfriend before chopping her up and hiding her in bags and teacups. He then chops off his own arm.

Now, using your knowledge and research of collage, have a go at the different methods I have suggested. Find inspiration by flicking through magazines, newspapers or even your old family photographs. Or find some narrative in a book, newspaper, film or song and use the various methods of collage to illustrate that.

drawing PEOPLE

Drawing my idols is something that I have been doing since I was a child, starting with Shakin' Stevens and Kim Wilde (don't laugh), then as a teenager, moving on to people like Jack Nicholson and Michael Caine, before noticing Kate Moss and then that was it – I never wanted to draw anyone else. *Most* kids have a go at drawing their idols, it's just another way of exclaiming your love for them because 'nobody understands! And if only he could meet me I'm sure we'd get on and he'd want to marry me!' Most kids grow out of this phase, but not Andy Warhol, and not me ... and maybe not you.

Now, I'm not going to waste any time here – drawing famous people is difficult. Mainly because everyone knows what they look like! You get the eyes one tenth of a millimetre too close together, or the lips a touch too wide, and your portrait of Angelina Jolie looks more like Steven Tyler looking like he just walked out of a salon.

So the trick to drawing people (if you wish to get a good likeness is (1) Look at the person, draw quickly, have fun, and see what you get! Or (2) Measuring. In fact, that is the key to drawing absolutely anything! It's basically about dividing and multiplying and measuring with your eyes and for someone who is as bad at maths as I am, drawing people now sounds like my worst nightmare! (3) Observation ... again. You may think that you know Ryan Gosling's jawbone inside out but if he had just mugged you and you had to describe his facial features to a photo-fit artist, how would you get on? Would Ryan get off scot-free because you've never really noticed how big his nose is before? (4) Go to life drawing classes. In most towns and cities, there are life drawing classes, often during the evening and for people of all abilities. Even if drawing people is not your thing, it will assist in so many ways creatively. (5) Practise. Practise. Practise. As I mentioned earlier, I've been drawing celebs for donkey's years now and quite often I still find it difficult to get the likeness.

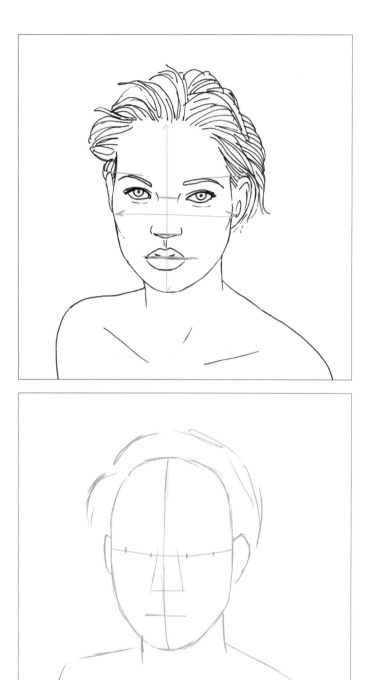

To begin with, start measuring vital points of the face. Sometimes it helps to squint when doing this, in order to blur the details and focus on the main shape and measuring points.

Measure straight down the centre of the face and then where vital points meet that line, and because the eyes are so important, I tend to start there. See how far you have to go down that line until the eyes meet it. Notice things like the arch of the eyebrow is level with the top of the ears and the cheekbones are exactly halfway down the central line.

Use these findings to draw your basic shape, marking out roughly where the features sit.

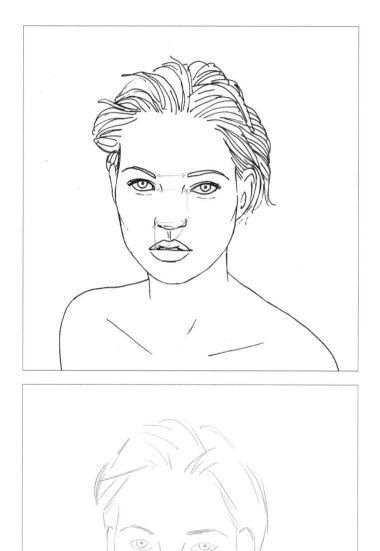

Then take in more detail.

There are often measurements on the human face that repeat themselves. For example: here we can see that the width of Kate Moss's nose is the same as the length between her nose tip and eye. The gap between her eyes is also the same measurement, as is the measurement between her nose tip and mouth line.

Start to add detail to your roughly marked out face. Keep checking these details before going too far. You don't want to spend two hours getting an eye exactly right, only to discover that it's in the wrong place!

When you are completely satisfied that all your features are the correct shape and in the right position, then start to add detail and your own drawing style.

You may want to trace over your drawing with a quick brush stroke or using other materials.

And remember what I said before: practise, practise, practise.

The French press claimed recently that Parisian women are taking to colouring in as a way of busting stress, as it's very therapeutic – and they're right!

I always enjoyed colouring in as a child. As much as I love creating my own drawings, sometimes it's nice to take someone else's drawing and just add the colour, without worrying whether the drawing is good enough. Enjoying colouring in so much myself led me to start creating my own range of colouring books. Quite often, when I release a new one, I will colour in one or two of the pages myself and post them to my Instagram account (@i_love_mel), and quite often many of my customers will ask which pencils, pens, or even colours I am using. So, for all of you colouring-in fans, I am about to share some tips and methods with you. But, as far as I am concerned, the most important aspect of colouring in is to relax. If you stress about Tom Hiddleston's hair going all wrong or not having the correct skin colour for Jennifer Lawrence, you're not going to get any of those therapeutic benefits that the French are going on about.

So, the first thing that many people ask me is: do I prefer using pencils or markers? The two are so different that it's very hard to pick one. If I want quick results without stressing about making errors, I opt for markers but, If I have a bit of time to kill and want to get a more realistic result, then pencils it is. Don't feel limited to those two options though. Try watercolours or gouache, make-up or even PVA and glitter!

So, right now I'm going to colour in the brilliant Thom Yorke from Radiohead using good quality colouring pencils.

(1) Start layering up the skin. People often ask me which colours I use for skin, and the truth is I use many different colours: beiges, reds, golds, pinks and even purples.

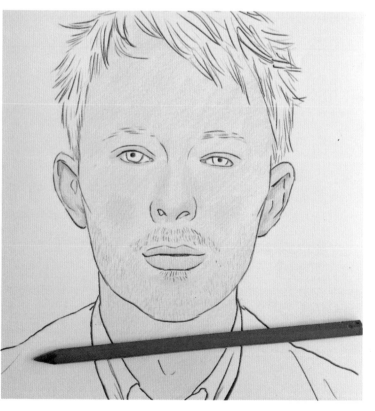

(2) Continue to layer the skin tones as these completely form the shape of the face. If you take your one 'flesh'-coloured pencil and lay down a flat colour, you're going to get a flat face.

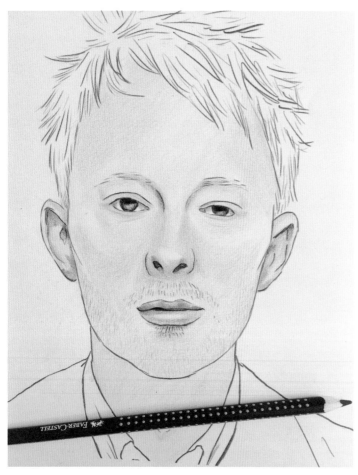

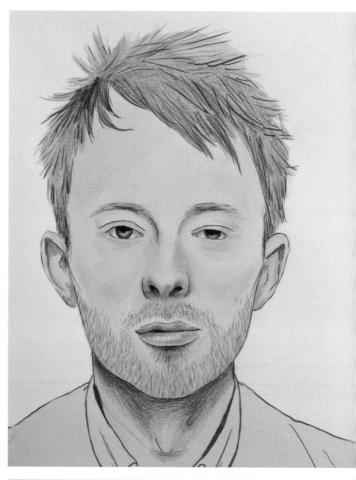

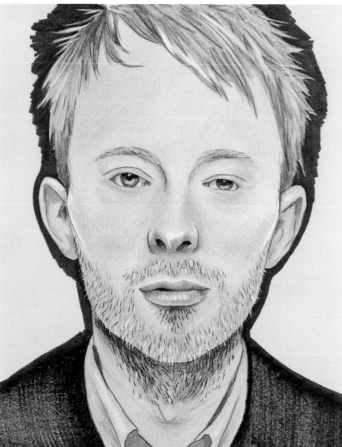

(3) Remember that eyelids form shadows over the eyes, creating different colours on the whites of the eyes, as well as the iris. People often make the mistake of drawing lower eyelashes directly onto the under eye line – when in fact there is a considerable gap.

(4) Shadows usually form under the jaw and contour around the shape of the throat. Use a good quality eraser to highlight cheekbones, lips, etc. There is often a highlight just above the eyebrow too, due to the skin being a bit plumper up there. Just like the skin, hair has many tones too. Start with a base colour and then add to this.

(5) You can use a soft white sketching pencil to add highlights to the nose end, lips, cheekbones and a few strands of hair and whiskers. However, I find a tiny bit of white gouache and a small brush does the trick. If you're going to do this, leave it right until the end and don't forget – you can't rub this out!

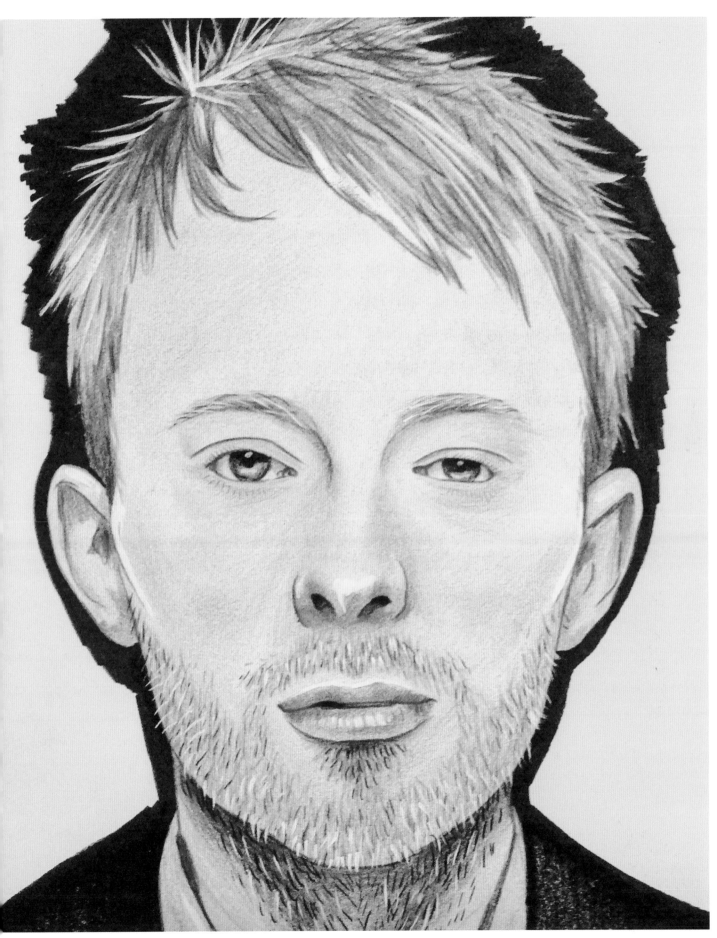

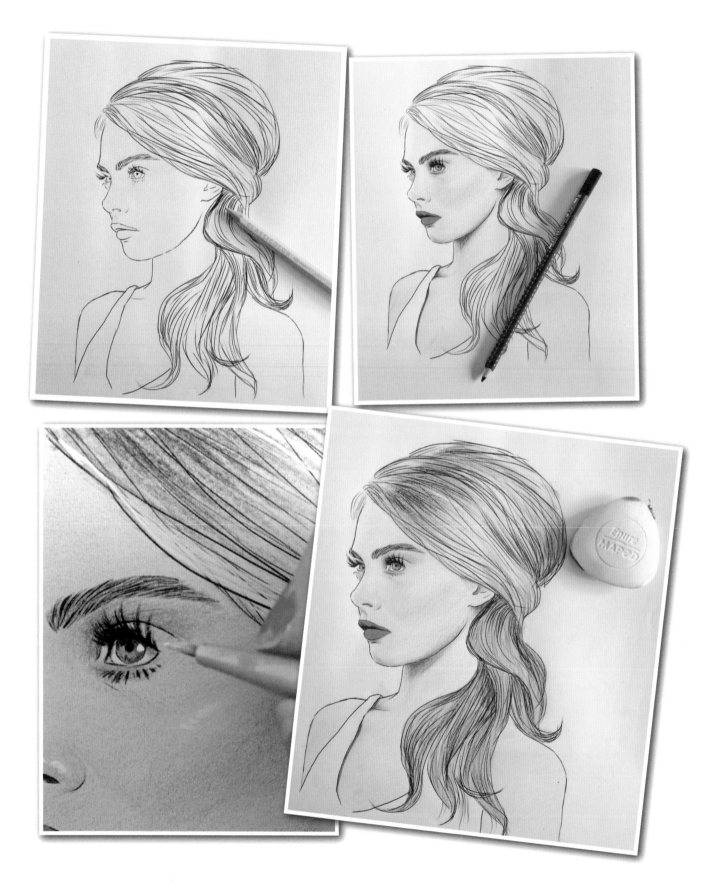

Here's a female example:
the beautiful Cara Delevingne.

For contrasting but utterly brilliant ways of using coloured pencils, check the work of Robert Nicol and Nina Cosford.

USING
MARKERS

Markers are such brilliant tools to work with – especially for colouring in or working on ideas.

They are quick and easy, with beautiful, natural and vibrant colours. Often they are refillable (which is good because for a large variety of colours, it can get rather expensive). With markers, mistakes are here to stay so it's best not to be too precious about your colouring in.

For me, the key to using markers for colouring in is to start light and then layer up, often using the same pen to go over certain areas to add density, light and shadows.

The disadvantage of markers is that your favourite and most-used colours dry up quickly (for me that is flesh tones, greys and black), but if they are refillable, refills can be bought for just the colours you require and certain brands sell singular pens too.

(1) Start with your base colour, leaving blank any highlight-heavy sections – in this case, length of nose and cheek bones. (2) Use the same shade to darken any areas needed, such as under cheekbones, temples, chin. (3) Repeat processes 1 and 2, as well as adding lip colour, again leaving blank highlights. (4) Use a darker shade on areas such as under cheekbones, under eyes, temples and under lips. (5) Use blacks, grey and other darker colours where necessary – note that the initial highlighted areas (nose and cheekbones) are still blank.

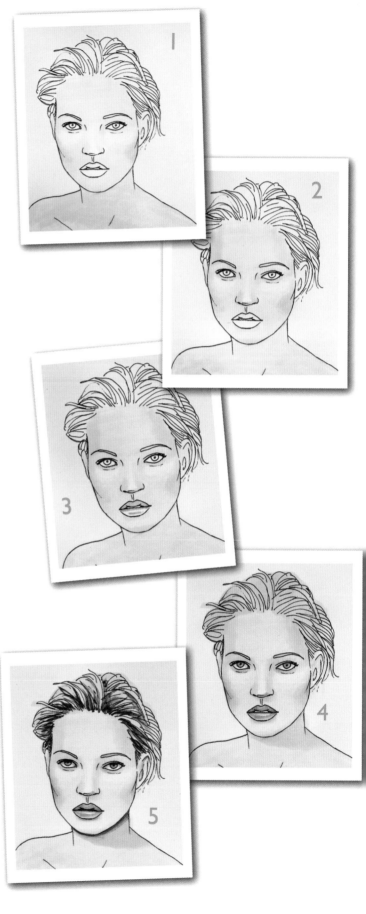

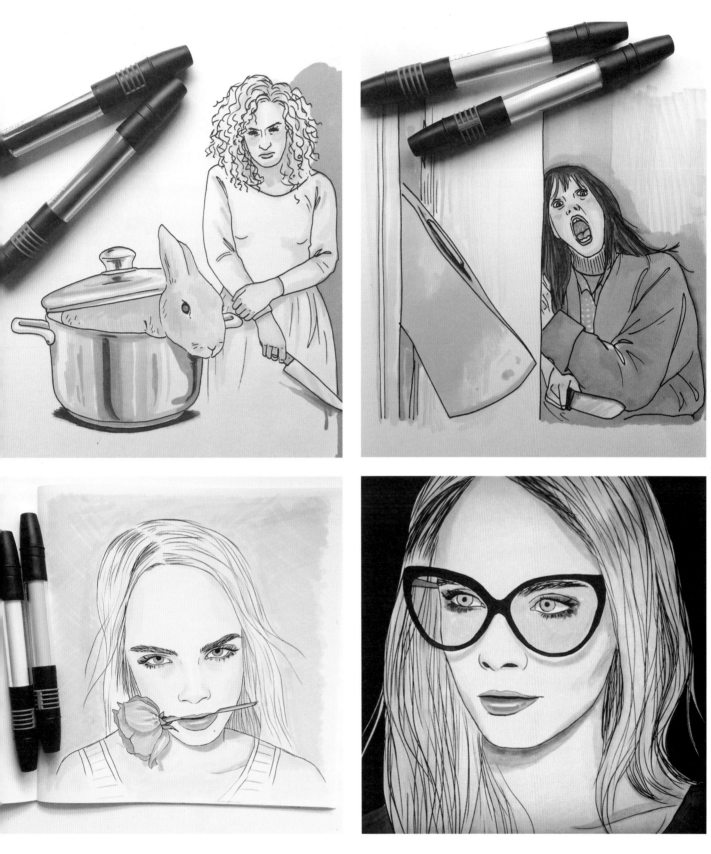

STOP-MOTION
ANIMATION

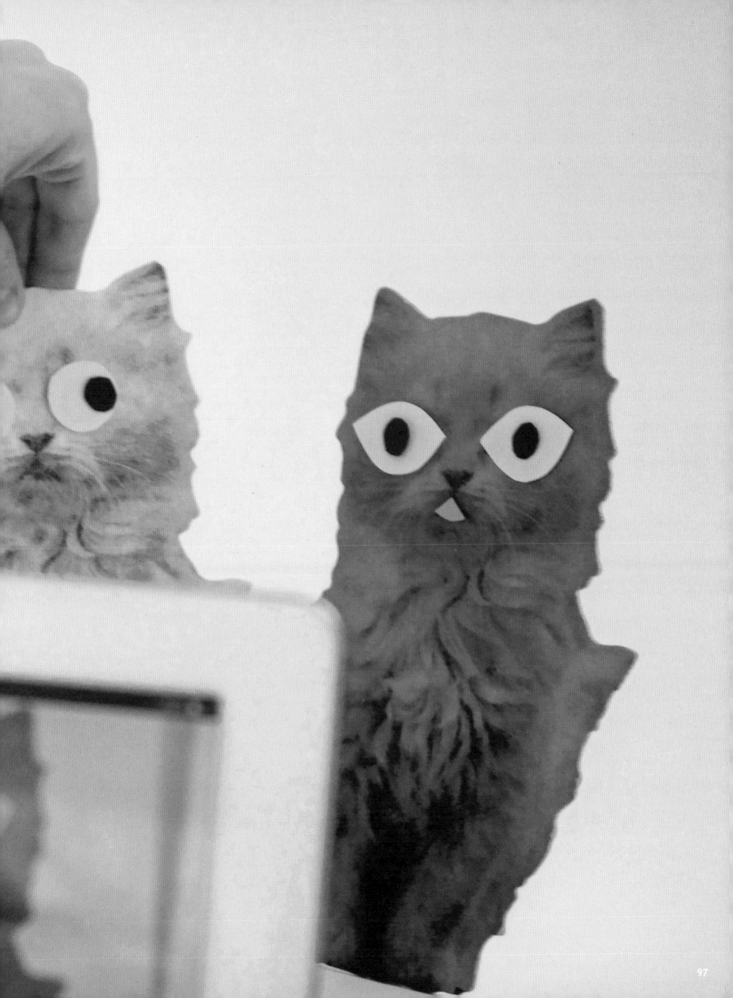

Thanks to wonderful new technology, stop-motion animation has never been easier for the creative novice, and it's such a fun thing to have a go at. Seeing something move and come to life merely through a click of a button is tremendously exciting, and the prospect of it can get your imagination running wild!

All you need to do this is a smartphone or tablet, and some stuff to animate. And that stuff can be pretty much anything.

You could get someone to stand still, take a snap, get them to take one step, then stand still while you take another snap, and continue to do this all around the room. The result will be that person moving about the room without moving their arms or legs!

One of the easiest stop-motion ideas is to get some stationery dancing around your desk, or some paper shapes performing a routine. The idea is to move something, take a photograph, move it again, take a photograph, and so on and so on. When all the photographs are joined together in quick sequence, the object, bits of paper, or whatever you are moving around, appears to be moving all by itself. And even though digital animation has become the front-runner, stop-motion is still used professionally and creatively all around the globe.

To make my stop-motions, I simply downloaded an app called iStopMotion. There are many apps that make this task incredibly easy and they range in price from free to not very much. Some will make it easier to edit, slow down or speed up frame times and add audio, while many of the free versions are great for just letting you have a go and seeing what the process entails.

For inspiration, check out the work of:

Hanne Berkaak and Marc Reisbig
Henry Selick
Nick Park
Tim Burton
Jan Svankmajer

You'll be surprised how often this technique is used in feature films and commercials, and you'll be amazed at what delightful, charming and innovative results can be achieved using stop-motion.

To produce my stop-motion animation, I selected two 'Flat Pets' by Garudio Studiage and decided to animate them re-enacting a TV conversation between Jimmy Kimmel and Justin Timberlake. They were to stay relatively still within the frame, with just their eyes and mouths moving to give expression and speech characteristics.

To do this, I cut out paper shapes and used Blu-Tack to attach them to the cats. I kept the pupils separate so that they could move around and added eyelids for blinking every so often.

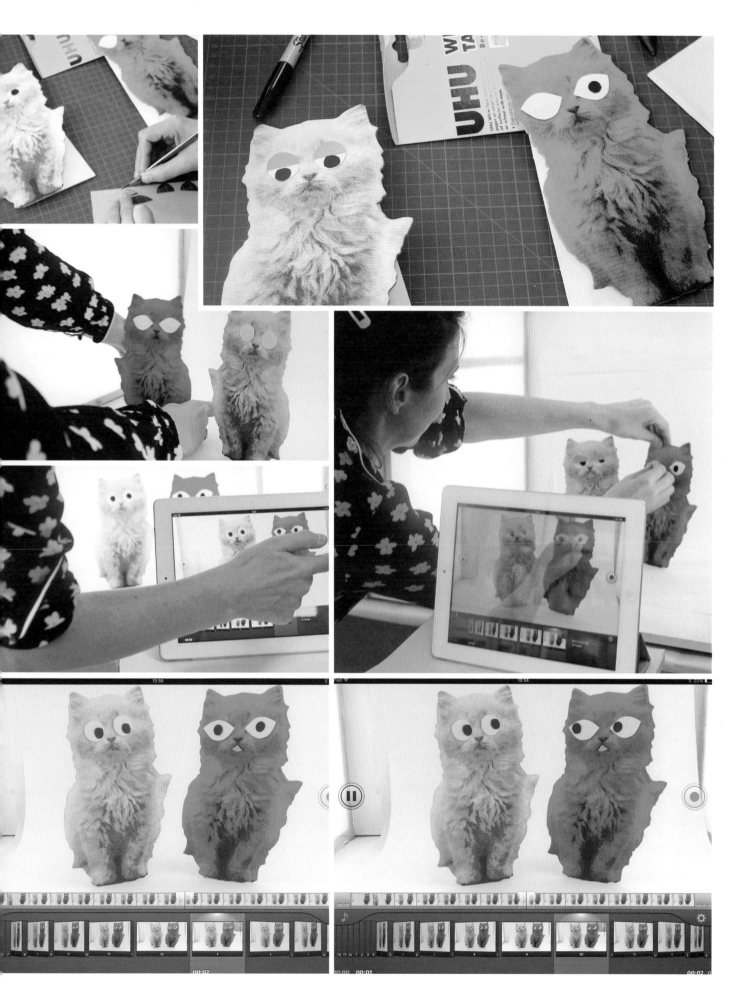

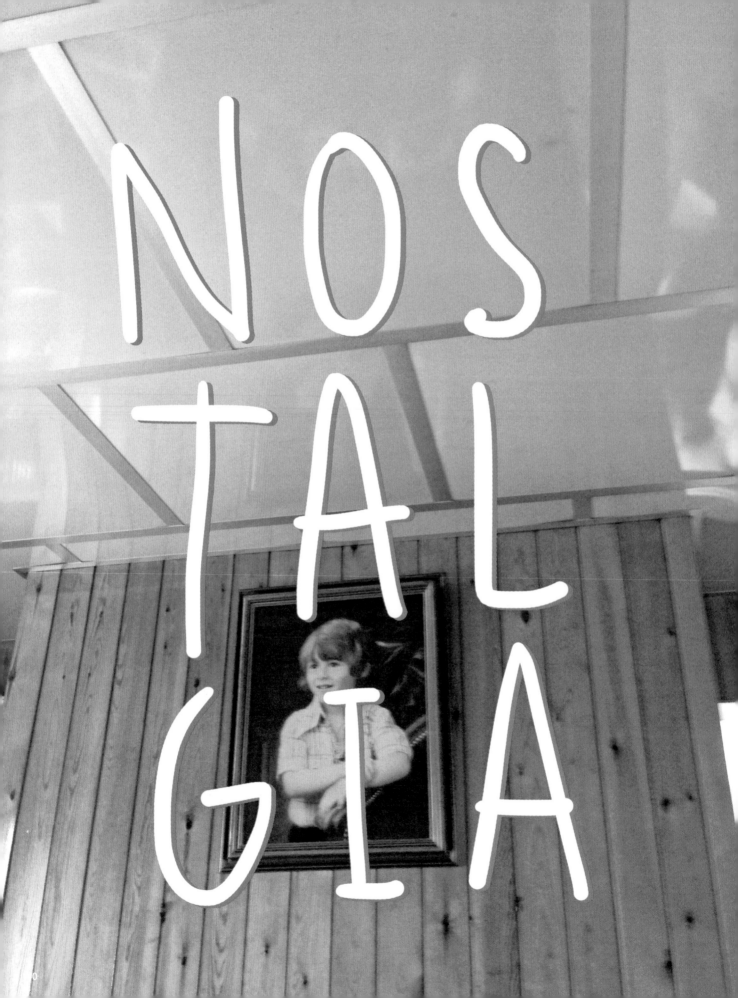

NOS
TAL
GIA

It is quite natural, as human beings, to hanker after bygone days. The times when your biggest worry was not paying the rent or meeting that deadline, it was 'Oh flip, I hope I don't get a puncture on my Raleigh Chopper, and I only have ½ p so they'd better have some Mojos at the corner shop!'

We love to look wistfully at photographs of our youth: the cars, the pop stars, the haircuts and the films. When one becomes a grown-up, those days just seem so wonderful in comparison.

Many artists, including myself, use a sense of nostalgia within their work and it is a subject that can manifest itself in many ways.

Personally, I often use packaging within my work, and make drawings, painting or prints that reflect my favourite sweets from my childhood (just like the *Lovely Bubbly* screen print on page 45). I also think that there's something really lovely about British seaside postcards from the 1970s and '80s, as well as knitting patterns, old cars, catalogues and magazine covers. Creatively, I find the designs and colour palettes incredibly inspiring.

While many creative people would argue that looking at the past is a very bad habit and that we should look ahead, be innovative and fresh, if looking at your past is an area you wish to explore, whether you romanticise it or demonise it, you go for it!

If you *do* wish to research this topic, look at:

Like a Dog Returns to its Vomit, the 2005 exhibition by Jake and Dinos Chapman, containing defaced and reconstructed pages from the Giant Bumper Colouring Books that were so popular with children before technology took over their spare time.

We Go To The Gallery by Miriam Elia — a book about contemporary art that mimics the style, innocence and teaching methods of Ladybird Books' *Peter and Jane* series.

Peter Blake's *Americana* collection explores nostalgia via collages of movie stars, childhood games, sports and other household objects.

Steve Gianakos's paintings often depict vintage cartoons, albeit with a sinister, often vulgar edge.

Injecting nostalgia into your work doesn't have to be a one-way street. Think of it more as one step back and two steps forward, and try to create your own fresh take on nostalgia.

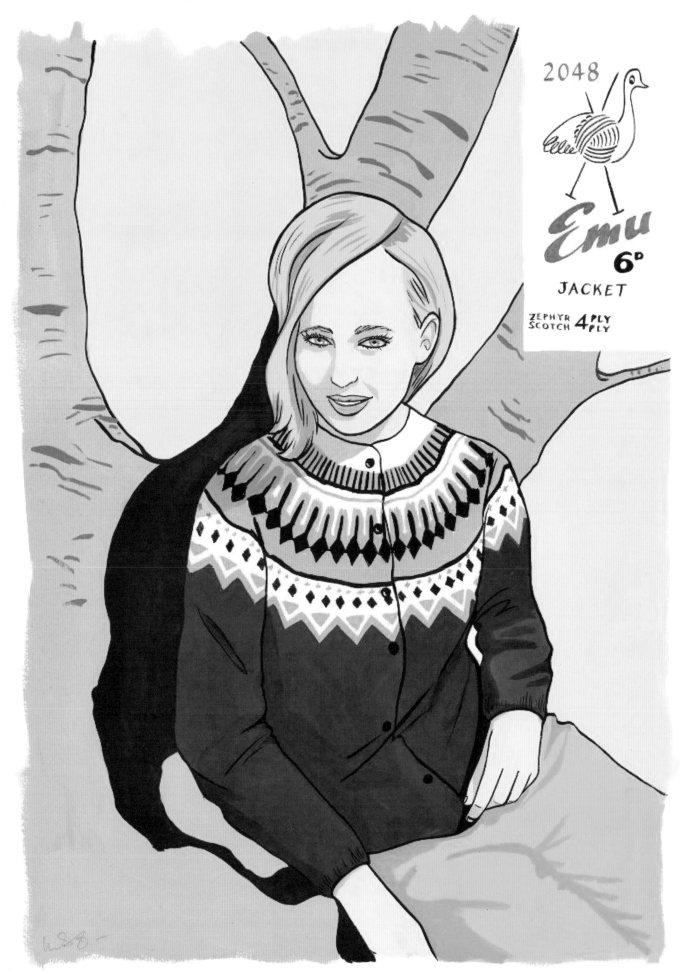

2048

Emu 6⁰
JACKET

ZEPHYR 4 PLY
SCOTCH PLY

Left *Fairisle*, gouache on paper.

Below *Infuriating To Live With*, two-colour screen print.

103

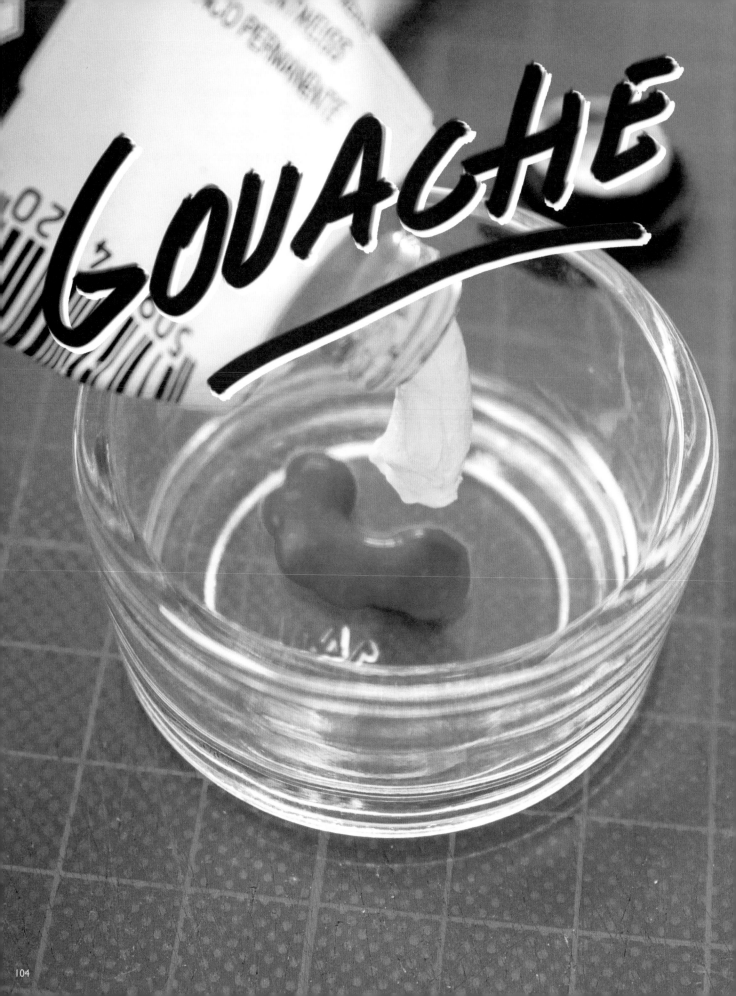

GOUACHE

There are many types of paints, inks and other substances that artists can use in all manner of ways, and having tried oils, acrylics and watercolours, gouache is my all-time favourite.

Incidentally, gouache is not a Hungarian stew. It is a highly pigmented, water-based paint containing gum arabic (and sometimes chalk) that creates an opaque finish, unlike traditional watercolour paints. When used in a certain way, it leaves a flat, velvety texture, but it can be used much more loosely too to give the impression of slightly thick watercolours.

When painting, I rarely use anything else, as I usually work towards a clean, crisp and flat aesthetic (which gouache is perfect for creating). In fact, the results can often resemble screen prints.

It is a very inexpensive medium that needs little equipment – just some water, a brush, something to mix in and something to paint on! It dries quickly too, so you can produce a painting and have it framed and on your wall within hours!

Do check out some artists who often use gouache so you can see the various ways it can be used, along with the versatile results that can be achieved:

Robert Nicol
Mimi Leung
Paul Klee
Jacob Lawrence
Henri Matisse
Anna Bond
Janice Wu
and me!

When I was a young teenager, I was taught how to 'lay flat gouache'. I was going to write 'and it took me a long time to master it', but I haven't, quite.

So what I am going to try and teach you now is just that, how to paint with gouache in order to create a clean, crisp, flat finish. Then I'll leave it up to you to decide whether you continue to use gouache and how you use it.

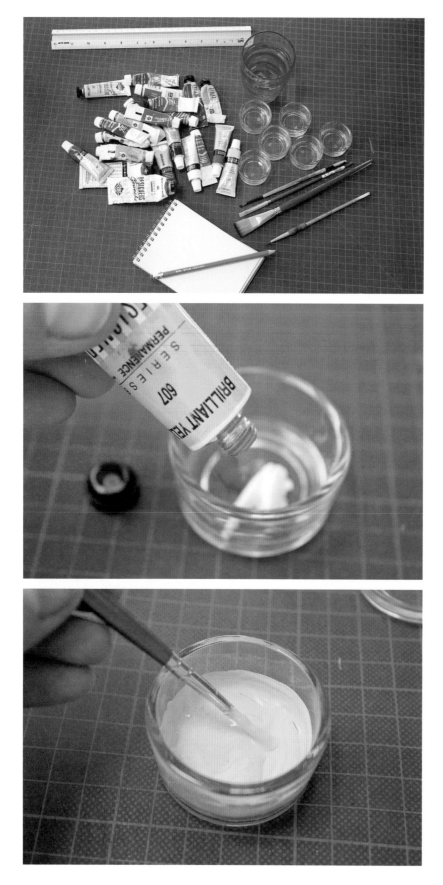

Get your paints, some water and a selection of brushes, paper, a ruler and something to mix in. I like to use little glass tea light holders but, since gouache is water-based, you can safely use your favourite plate or whatever you fancy.

When I need to use larger quantities of the same colour, I use foil takeaway cartons and then throw them away.

Using paint straight from the tube is plain lazy. Spend lots of time practising mixing colour: it is so important to be able to chose your own colour palettes rather than have them dictated to you. A good exercise is to take some domestic paint swatches from the DIY shop and try to match them.

Tip: Gouache tends to dry darker than it is in its wet form.

Mix your desired shade with a little water.

To get a crisp, flat cover, the consistency should be like double cream.

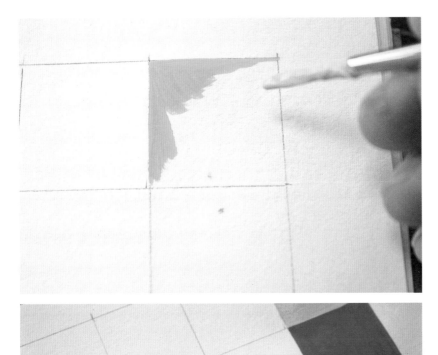

Draw yourself a grid or some other geometric shapes and, beginning at the edges, start filling them in.

Practise getting flat, neat and concise shapes that do not blend into one another – although gouache is great for blending techniques too!

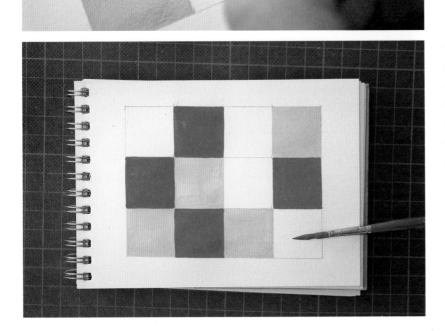

Continue doing this before moving onto larger areas, while still trying to achieve a flat, velvety finish. To do this, make sure that your brush size relates to the area that you are painting and ensure that you have enough paint mixed.

Left *Graham*, gouache on mount-board 60 x 80cm.
Below *Tavi*, gouache on paper, 50 x 40cm.

PATTERN & SYMMETRY

PATTERN & SYMMETRY

While I have always loved pattern, I had also considered it a pleasure for textile designers only. I love to wear vibrant patterns on my back and have them on my cushions at home, but I never considered there would be a place for pattern within my work. Then, one day, I came up with the idea of developing a card game called *Seeing Double*. The illustrations for the front were easy, but then what about the back? They all had to be identical and they had to look great. This was when I realised that pattern *had* to play a part in my work, and I have a feeling it will continue to do so.

So where do you begin when you want to start playing with pattern? Pattern can mean all sorts of things, but for me the simplest way to begin my journey into the unknown was to combine geometry with symmetry. So, I began with some graph paper ... then I started doodling on it.

Another great way of creating pattern, is to cut some small, coloured shapes out of paper and move them around the grids.

You could also try washi tape, children's coloured wooden building blocks, Lego, leaves, coloured sweets, use your imagination!

Once I had a vague idea of what I wanted, I then used Adobe Illustrator to draw and fill my shapes before positioning them, stepping and repeating. It's a bit like dancing really!

For a brilliant insight into pattern take a look at patternity.org. Patternity are a design duo who 'see pattern everywhere – the mundane to the magnificent', with their research consisting of recognising pattern formations in buildings, slices of meat, water and pretty much everything else in between. They then use this methodology to design their own patterns, which have been put onto plates, shoes, rugs and even buildings.

For more pattern inspiration, look at the work of:

Cristian Zuzunaga
Lucienne Day
Julia Chiang
Deborah Bowness
Yayoi Kusama
Piet Mondrian
Damien Hirst (his butterfly work)
Matthew Collings

Pattern can be created by reflecting almost anything to create symmetry.

In order to make the wall stickers opposite, I collaged together some of my favourite pop culture icons from the 1990s, made each item tiny, then reflected and repeated them to make a shape reminiscent of a flock wallpaper motif. I then printed them out and positioned them on a wall to create the look of a very traditional wallpaper, while featuring images of Pokemon, mobile phones, Britpop and *Dawson's Creek*!

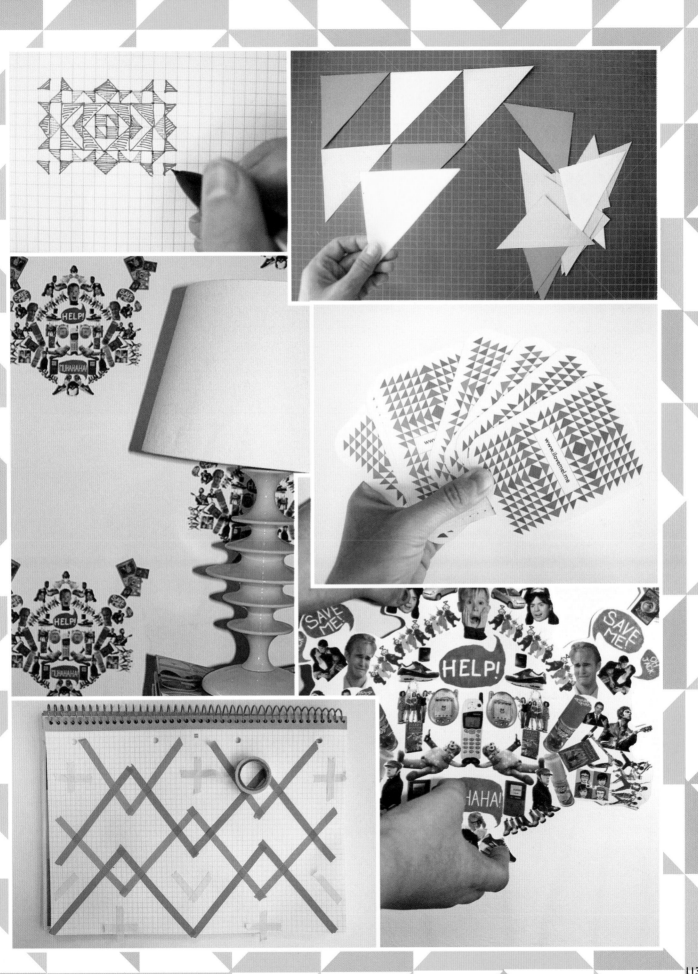

IT'S A WRAP!

Since I was a very young child I have enjoyed drawing and painting graphics and lettering. I would spend hour upon hour drawing cereal boxes and biscuit and sweet wrappers, and just like my early fondness for drawing celebrities, it has never really stopped. Remember my *Lovely Bubbly* screen print?

Drawing boxes or wrappers that contain lettering is a fantastic lesson in composition, as attempting to get all the wording positioned correctly (so that your small drawing of a Twix wrapper doesn't end up being 3m long) is quite a difficult thing to do.

So have a rummage in your kitchen cupboards, or pop down to treat yourself at your favourite sweet shop. Eat the contents and get drawing!

Coloured pencils are great for this type of work but if you want to test your new-found gouache skills, this is a great exercise for that.

Start off simple. For example, if you are to draw a crumpled-up KitKat wrapper, concentrate on the main logo, ignoring any small ingredients text.

Get inspired by looking at the work of Ed Ruscha and Andy Warhol.

Left My homage to Andy Warhol's *Brillo Boxes* for the cover of one of my colouring books.

ACCIDENTSWILLHAPPEN

(learn to love them!)

For a short time, I worked for an advertising agency called Wieden + Kennedy and their motto was 'Embrace Failure'. In fact I'm certain it still is.

Before working there, I was taught about 'happy accidents' by my art tutors, and it wasn't until late one evening that I understood what they meant by it.

During the time many years ago when I was forced against my will to make some collage, I took my work home. I sat in the middle of my living room floor, cutting up old receipts and newspapers, trying to be all big and clever and make a comment about the price of high fashion. I was not happy to be doing this, but, as I was being forced, I continued, with only an expensive bottle of wine to keep me going.

Just as I was sticking the last piece onto my collage, I knocked the bottle of wine all over my work, thus creating the biggest mess of red wine, posh frocks and receipts that one would ever witness ... but it worked! All of a sudden, what was a lame comment about expensive shoes, became a much better comment about being forced to make a collage, and then spilling red wine all over it right at the finishing post.

And that, ladies and gentlemen, is a 'happy accident'. When you are creating, if you're doing it correctly, you will have many of them. When you click the wrong button on Photoshop and everything changes, sometimes you will click EDIT > UNDO, but then other times you will say to yourself 'Woah, that looks kind of cool like that!'

So my piece of advice is:

Make lots of mistakes, because sometimes they're where your best ideas will come from.

How do I get
my work seen?

You are lucky enough to live in an era where we have this fancy new modern thing called the Internet, and guess what? It makes showing off so easy – *too* easy in fact! You must have friends on Facebook who have loads of #HappyDays, eat tonnes of scrummy meals, go on millions of perfect holidays and buy masses of lovely goodies. Well, now it is time for you to be one of them ... but in a creative way.

Use the Internet to your advantage:

Facebook is great for joining groups of other creative people, local or otherwise. Often they will show one another their work and even organise joint exhibitions.

Like your local galleries on Facebook too. The more you interact with them, the more they know of you and your work. Then one day, just ask them to let you know if/when you can exhibit there, either alone or as part of a group show.

Like your local cool and trendy bars and restaurants. Many of them act partly as galleries too and like to keep refreshing the art on their walls. Pick the ones that encourage the right type of people who may buy your work.

Start your own Facebook page and encourage your friends and family to like it and share when you post new work on there.

Instagram is a great platform to show your work on and if you're good (which I'm sure you are!) people will follow you. It may take time, but they will.

Find out if there are creative social groups in your area and go along to meet them. They usually take place around a warm pint of beer and everyone discusses their latest project, whether it be a book, an exhibition, a piece of street art or whatever. They are a great place to make like-minded friends and find out about the local art scene.

Collaborate!
Like what someone does? Ask them to join you on a project or two.

Make your own online shop – these days most people know someone who has the skills and knowledge to make this happen.

Make some artists' multiples or products and become a salesperson – walk around gallery shops and gift boutiques selling your wares. Write and send samples to buyers at larger stores.

Think small – put your work onto greetings cards or stationery, tote bags or badges. They are cheap to produce and fairly easy to sell.

Think BIG – ask your local council if you can create an event, such as a large exhibition, a site-specific piece or a performance piece.

Check out local, national and international design festivals and see if you can get involved.

Enter competitions – many art and design competitions are listed in artist newsletters, prizes are often print publishing contracts, exhibitions or even cash!

The main thing is to not sit in your room thinking that your work is terrible and no one wants to see it. Get out there and make a splash!

Now you can make

absolutely anything!

If you were expecting this book to teach you how to draw, I am genuinely sorry if you are disappointed. While I have tried to teach you a few techniques, my main aim with this book is to teach you *How To Make Art*, hence the catchy title! And making art isn't about learning to draw, as by now I am sure you have realised. Making art is about YOU and only you can teach yourself. But I hope I have started you off.

This book has had you evaluating your likes and dislikes, it's had you staring at things for hours on end, sitting embarrassed while you draw in public and describing your artwork with a limited palette of words. It has made you research other artists and step away from the Internet now and then, it has had you searching in the unlikeliest of places for inspiration and ideas. It has given you projects to get you thinking, projects to get you working, and projects to give you some fresh air.

It has provided you with an overview on many different techniques and practices, from screen printing to using markers and paint, and even no-frills drawing with a plain old pencil. It has shown you traditional and digital methods and hopefully it has left you with all the tools you need to stand up nice and straight, exclaim with confidence that 'you are a creative person' and go ahead and be just that, with a knowledge and understanding of yourself, what makes you tick and what kind of art you wish to make.

There are just two more pieces of very important information that I have for you:

(1) *Enjoy* your creative life. If you are not enjoying it, you're doing it wrong. Creating should be a pleasure and a joy, so if it ever feels like a chore, step back and take a look at what you're doing. Maybe you need to do things completely differently.

(2) Believe in yourself. If you don't love what you've made, why should anyone else? Just as with many things, confidence plays a great part in success. Don't look at the work of other people you admire and consider yourself to be inferior. Just because you can't paint like Chuck Close, it doesn't mean your work is any less important – it makes you different. You are not Chuck Close, you are you!

(3) Embrace technology. Even if the traditional practices are more your thing, let technology assist you. Artists have always used what is available to them at the time to make their lives easier, to help them create faster thus letting them create more art. Don't feel guilty about using all the amazing technology we have in the 21st century, that's what it's there for.

'Don't think about making art, just get it done. Let everyone else decide if it's good or bad, whether they love it or hate it. While they are deciding, make even more art.'

Andy Warhol

SO WHAT ARE YOU waiting FOR?.

Books by Mel Elliott

"If you thought that was good now you listen to me,
I can count really fast, listen, ONE TWO THREE."
She carried on counting right past a million,
and Pearl didn't stop 'til she reached ninety-billion!

"Don't laugh at me for getting things wrong,
for I am a girl who's clever and strong."
Sebastian frowned, "That's stupid" he snapped.
All the other kids cheered and clapped.

Colour Me Swooooon
Colour Me Girl Crush
1980s Bumper Activity Book

Pearl Power

Colour Me Good Harry
Colour Me Good James Franco
Colour Me Good Chairs
Colour Me Good Tom Hiddleston
Colour Me Good Benedict Cumberbatch
Colour Me Good Ginger
Colour Me Good Ryan Gosling
Colour Me Good 80s
Colour Me Good 90s
Colour Me Good Fashion
Colour Me Good Hip Hop
Now That's What I Call Colour Me Good Record Sleeves
Colour Me Good Modern Art
Colour Me Good Arrggghhhh!!
Colour Me Good London
Colour Me Good Kate Moss
Colour Me Good Cara Delevingne

Beyoncé Paper Doll Book
Bowie Paper Doll Book
Debbie Harry Paper Doll Book
Rihanna Paper Doll Book
Ryan Gosling Paper Doll Book
Simon and Garfunkel Paper Doll Book
Top Twerker Paper Doll Book

Seeing Double (card game)

It's time to sail off on your creative adventure...

Maybe I'll see you along the way somewhere!

POSTCARD

Hastings, United Kingdom

Mel Elliott was born in Barnsley, South Yorkshire and studied at Batley School of Art & Design before moving on to The Royal College of Art. She now lives and works on the south coast, in Hastings.

I LOVE MEL was formed in 2009 as an independent publishing label, under which Mel has produced several *Colour Me Good* grown-up colouring books, as well as *Pearl Power*, an illustrated children's book and *Seeing Double*, a card game. Including this one, she has produced four books for Pavilion: *1980s Bumper Activity Book, Colour Me Swooooon* and *Colour Me Girl Crush*.

With thanks to Jack Girling and Charlie Blessed
for their ideas and contribution.

See more of Mel's work at www.ilovemel.me
or follow her @mellyelliott

First published in the United Kingdom in 2015 by
Portico
1 Gower Street
London
WC1E 6HD

An imprint of Pavilion Books Company Ltd

ISBN 978-1-90939-680-7

A CIP catalogue record for this book is available from the British Library.

10 9 8 7 6 5 4 3 2 1

Reproduction by Colour Depth Ltd, UK
Printed and bound by 1010 Printing International Ltd, China

This book can be ordered direct from the publisher at www.pavilionbooks.com